forgotten TALES

of

MICHIGAN'S
Upper Peninsula

forgotten TALES of MICHIGAN'S Upper Peninsula

Lisa A. Shiel

illustrations by
Kyle McQueen

Charleston — London

THE
History
PRESS

Published by The History Press
Charleston, SC 29403
www.historypress.net

Copyright © 2010 by Lisa A. Shiel
All rights reserved

First published 2010

Manufactured in the United States

ISBN 978.1.59629.916.0

Library of Congress Cataloging-in-Publication Data

Shiel, Lisa A.
Forgotten tales of Michigan's Upper Peninsula / Lisa Shiel.
p. cm.
Includes bibliographical references.
ISBN 978-1-59629-916-0
1. Upper Peninsula (Mich.)--History--Anecdotes. 2. Upper Peninsula
(Mich.)--Social life and customs--Anecdotes. 3. Upper Peninsula
(Mich.)--Biography--Anecdotes. I. Title.
F572.N8S55 2010
977.4'9--dc22
2010025548

Contents

Introduction 7

Quakin' and Shakin' 9
The Wild Woods 17
Up a Creek…Or a Tree 27
The Lost and the Found 41
Flying Fists and Sharp Tongues 51
Tales of the Rails 61
Ripped Off 71
Done In, Done Wrong 85
The Bad Guys 99
Duped Yoopers 107
Tales of the Inland Sea 119
Lore of the Folks 129
And the Rest… 137

Bibliography 167
About the Author 176

Introduction

In 1836, before becoming a state in January 1837, Michigan fought a pseudo-war against Ohio over possession of a strip of land that included Toledo. The Toledo War ended when Michigan agreed to give up the Toledo Strip in exchange for two things: statehood and—in hindsight, more importantly—the territory known as the Upper Peninsula (UP). At the time, citizens of Michigan may have had their doubts about who came out on top, but soon the riches and wonders of the UP became evident. The northern peninsula would attract miners, con men, tycoons and literal gold diggers.

Today, residents of the Upper Peninsula call themselves "Yoopers" and celebrate their distinctiveness. In the old days, folks who moved to the UP might have found themselves labeled foolish at best or lunatics at worst. Pioneers came here in search of a better life, miners and lumbermen came looking for work and businessmen came

in hopes of cashing in on the copper and iron industries. The diversity of the people who immigrated to the UP from places as far-flung as Cornwall and Italy forged the region's unique character—and, in the nineteenth and early twentieth centuries, sometimes inflamed passions.

From brawls to murders, from strange creatures to unsolved mysteries, the early days of the UP had it all. Yet the vast majority of the region's history languishes in obscurity, hidden in old newspapers and forgotten books. Everyone hears about Bishop Baraga, but who remembers Brig Shove? The story of Mr. Shove, along with tales of many other forgotten folks, colors the pages of this book. Their exploits span the spectrum from the silly to the sinister, from the bizarre to the brutal. The forgotten history of the UP will be forgotten no more.

Oh, and as for who got the better deal in the Toledo War...well, we Michiganders got copper and iron and lumber and gorgeous scenery and even a bit of gold and silver. Ohio got...Toledo.

'Nuff said.

Quakin' and Shakin'

Everyone knows about earthquakes on the West Coast. Anyone who moves there better take a hard hat. When folks move to Michigan, they expect stability—from the earth under their feet, at least. Southern Michigan has on occasion felt leftover tremors from quakes along the New Madrid fault in the Mississippi River Valley. But most visitors to the Upper Peninsula, and even most residents of the UP, are unaware of the region's seismic history, full of bumps that could put a roller coaster to shame.

Hot-Air Blasts

Scientists draw a gray line between tectonic, or natural, earthquakes and temblors caused by explosions, mine collapses and similar events. An earthquake in April 1793 in the Porcupine Mountains of the western UP is the sole

natural quake recognized by modern-day scientists. Mother Earth took a 110-year break to rest up for her next volley, a series of more than twenty quakes that rattled the UP between 1902 and 1909. The brunt of the shaking struck the Keweenaw Peninsula and centered on the towns of Houghton, Hancock and Calumet in the UP's Copper Country, so called because of the district's rich deposits of copper. Over forty thousand people lived in the three towns, with the majority living in and around Calumet, thanks to the Quincy Mine, the largest copper mine in the region. Calumet was already a bustling metropolis by the time the first tremors were felt in 1902.

According to a report in the *Daily News-Record*, a Sault Ste. Marie paper, on November 7 a "severe shock…accompanied by a rumbling sound" frightened residents of Houghton and Hancock. As their houses shimmied and their dishes clattered, people couldn't help but recall a similar incident three months earlier and wonder what was happening. A week later, authorities declared the quake had resulted from an "air blast" on the seventy-ninth level of the Quincy Mine. Case closed.

Not so fast.

The *Daily News-Record* described the cause of air blasts as "a mystery to mining men" because the blasts only happen in abandoned sections of mines. With no one around to witness them, air blasts became a convenient and reasonable-sounding scapegoat. Meanwhile, Wisconsinites found a lighter side to the terrifying shocks felt in the Copper

Country, with the *Racine Weekly Journal* explaining that the "alleged" quake was "probably nothing but late election returns." Given the frequency of brawls between miners, maybe the tremors happened when a big Cornishman pounded an Irishman into the ground.

Another air blast of unknown origin shook the Quincy Mine and its aboveground vicinity on November 15. Four days later the *Benton Harbor Daily Palladium* quoted an unnamed mining engineer, who explained that the air blasts resulted from "terrific pressure" on rock pillars in the mine, which caused them to collapse, sending out shockwaves felt on the surface. If the news relieved residents, the effect was short-lived. On November 22 the *Ironwood Times* reported an unsettling bit of news about the November 7 quake. An investigation into the air blast theory had found no evidence of such blasts.

Folks may have felt certain someone was blasting hot air, but no one knew which report to believe. The situation would only get more confusing two months later.

EXPLOSIVE SITUATION

On January 27, 1903, the flustered folks of northern Houghton County felt the earth shiver beneath their feet once again. Some of them may have thought God was wreaking his vengeance on the sinful citizens of the mining district, while others just felt unlucky. The morale of Copper

Country residents may have lifted a bit, though, when they found out the tremors emanated from an explosion at the powder works in Marquette, one hundred miles away. No one died in the explosion, but the tremors rippling out from it reignited old fears.

The following month the earth rumbled again, this time in the southern UP town of Escanaba. At 7:30 p.m. on February 17, residents of Sarah Street felt the first quivers. An hour and a half later, a larger tremor affected the entire west side of town, rattling dishes and setting dogs barking and babies crying. No one knew what caused the shaking. Another quake of unknown origin hit Calumet the following summer. The so-called air blasts in the copper

mines on the Keweenaw continued too, according to a report from the *Marshall Expounder* in December 1904:

> *Atlantic, a mine location and a town of 3,000 people, was shaken by an air blast in a local mine similar to the mysterious air blasts occurring every few months at the Quincy mine at Houghton. Hundreds of tons of rock were dislodged and the general effect was that of an earthquake.*

And the quakes kept spreading. Houghton felt a mild tremor on February 8, 1905. On March 13 an earthquake occurred in the town of Menominee on the Wisconsin border. Modern estimates gauge the shaking on that day at about a magnitude 3.8 on the Richter scale (based on eyewitness accounts, since no one in the area had a seismograph). Perhaps an explosion caused the quake, perhaps not. A century later, no one can say for certain. On June 4 a landslide triggered a minor earthquake in Sault Ste. Marie, aka "the Soo." All of these little quakes turned out to be the opening act. The headliner took the stage that summer.

THE CALUMET EARTHQUAKE

July 26, 6:30 p.m. Residents of Calumet heard a loud boom, like an explosion. The boom set off an earthquake that knocked down so many chimneys throughout the Greater Calumet

area that Houghton's *Daily Mining Gazette* said chimneys were "falling everywhere" in the town. South of Lake Linden, the quake shifted the O'Shea residence an inch off its foundation. Plate glass windows shattered. The interiors of some buildings suffered damage too. The initial boom was heard from Copper Harbor, at the tip of the Keweenaw Peninsula, all the way down to Marquette. The earthquake itself jarred people all over the Keweenaw and reached as far down as the forty-ninth level of the Calumet & Hecla Mine. The shaking lasted ten seconds. A second, softer boom was heard at 8:20 p.m., followed by a softer quake lasting two seconds.

Naturally, the topic of air blasts came up again as the proposed culprit of the quakes. In August, Fred W. McNair—president of the Michigan College of Mines in Houghton—told the *Daily Mining Gazette* that he thought the earthquake of July 26 stemmed from a slipping of the faults hidden under the Keweenaw, perhaps exacerbated by mining activities. The Hancock fault runs straight through the Quincy Mine. Geologist William Herbert Hobbs concurred:

> *It is* [my] *opinion these earthquakes were due to natural causes—an uplift of the land—but modified in their expression by the peculiarly unstable conditions brought about by large mining operations.*

The strange goings-on in and around the mines continued into the next year. Another air blast struck the

Quincy Mine in February 1906, damaging all but one shaft and driving one hundred miners to quit. Other residents took their cues from the miners and fled the area in fear.

The Atlantic Mine south of Houghton became the epicenter for weirdness on May 26, 1906. Railroad tracks above the mine were deformed, bent into S-curves that could derail a train. The seismic disturbance muddied the waters of a nearby swamp. A section of the mine at the surface had caved in too. Investigators found a crack in the earth above the mine and grass "pushed up into a roll like the so-called 'mole tracks' of earthquakes," as Hobbs related in his 1911 report on the quakes. Unlike the Calumet earthquake, this time a makeshift seismograph set up by state geologist A.C. Lane detected the tremors associated with the observed phenomena at the mine. A series of shocks happened that morning, the first at nine o'clock, another at ten o'clock and a third at eleven o'clock. As with the Calumet quake, Hobbs believed this one was reinforced by the mines themselves.

Intermittent quakes would follow in the subsequent decades, including one in 1925 that damaged the state hospital in Newberry, but none matched the panic of 1905–6. Modern scientists dismiss the quakes as the result of explosions or mine collapses. Nevertheless, today visitors to the Quincy Mine—now a tourist destination as part of the Keweenaw National Historic Park—can poke their fingers into the Hancock fault running straight through the mine and under U.S. Highway 41.

The Wild Woods

The pioneers who first settled the UP found a densely forested landscape full of never-before-seen wonders, both in the geology and the wildlife. Some of the wildlife proved wilder than others. Today everyone has heard of Bigfoot, the manlike monster clad in a natural fur coat. Back in pioneer days, before the coining of the term "Bigfoot," folks applied a different label to the mysterious manlike creatures haunting the woods—wild men.

Mistaken for a Lynx

Here in the twenty-first century, debunkers will propose any old explanation, no matter how ridiculous, to dismiss Bigfoot sightings. Little has changed in the past hundred years. Take the case of a young man from Rosedale, south of Sault Ste. Marie, who reported seeing a wild man in the

woods in October 1904. The sheriff, busy attending a local fair, handed off the report to his undersheriff—who in turn handed it off to the county jailer. The jailer, "Turnkey" John Fleming, rushed to Rosedale to investigate. The sighting had frightened locals so terribly that some kept their children home from school.

Fleming told the *Evening News* that the unnamed witness described "a man running through the woods, bare legged below the knees and clad only in light clothing." Fleming, however, offered up another explanation. The witness saw a wild animal and, overcome with fear, mistook the animal for a wild man. Fleming said, "I guess the fellow saw a lynx."

In Rosedale, visitors better watch out for upright-walking lynxes.

THE DEER RIVER WILD MAN

The town of Crystal Falls sits in the western UP, not far from the Wisconsin border. In 1901 residents of the Crystal Falls area experienced wild man fever firsthand. On October 9 hunters reported seeing a wild man near the headwaters of the Deer River, fourteen miles outside of town. The hunters approached within thirty feet of the wild man, who was wolfing down a dead skunk. The wild man snarled at the hunters before taking off into the cover of the woods. A report in the *Soo News-Record* described the creature as having long hair and toting "a piece of gunbarrel and a

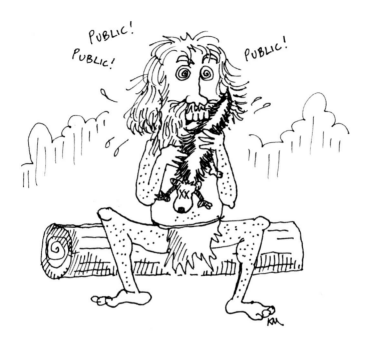

tent pole." The hunters thought some of his snarls sounded a bit like the word "public," leading them to the conclusion he hailed from the town of Republic. A later report in the *News-Record* described the sounds as "unearthly yells not unlike a dog's bark." A posse was dispatched to hunt for the wild man.

While today bears are the favorite scapegoat for Bigfoot sightings, in olden times debunkers favored the escaped lunatic theory. The first news reports suggested that an

average man had become lost in the woods and consequently lost his mind. Two days after the sighting, the *News-Record* painted a slightly different picture:

> *In the absence of any positive information it is barely possible that the alleged wild man discovered by Crystal Falls hunters is just some manufacturer who went into retirement for a few days and has not heard that the tax commissioners have returned home.*

After three days in the woods, the posse gave up the search. Despite finding numerous footprints, the searchers returned with no more clues to the wild man's identity than they had when they left. The wild man made a few more appearances, including terrifying a lumberman with his "unearthly yells," but evaded capture.

In December 1901 a local attorney claimed to have solved the mystery. Shortly before the first wild man sightings, a Milwaukee insane asylum requested information from the attorney about land in the Deer River area owned by one of its patients, John Johnson. The attorney provided the information and forgot about it. Then, a few days before the first sighting, the attorney read in the newspaper about a patient named John Johnson who had escaped from an asylum in Milwaukee. Surely, he thought, this must be the same John Johnson. Speaking to the *Soo Daily News-Record* two months later, the lawyer felt certain the escaped mental patient had "sufficient mental power" to traverse the two

hundred miles from Milwaukee to Crystal Falls physically intact. A Sault Ste. Marie newspaper declared the attorney's story had "the color of plausibility." Yet could a man so insane that he dines on skunk tartare and frightens tough lumbermen with his unearthly screams survive a two-hundred-mile trek in the chill of the late fall?

All explanations for the Deer River wild man remained hypothetical. The "hideous creature," whether man or beast, was never captured.

SIDESHOW WILD MAN

Sightings of wild men became so prevalent that traveling carnivals began featuring supposed wild men in their exhibits. Ads in newspapers would tout each carnival's wild man as the wildest and most fearsome of all. In the early part of the twentieth century, the Elks Lodge in Sault Ste. Marie boasted a wild man at its annual bazaar. A gentleman called Max Schoeneman presided over the Pike, a series of exhibits depicting wonders from around the world. The Pike included a man-eating tiger, singing ducks and a wild man. Unfortunately, four days before the opening of the 1908 bazaar, the wild man escaped overnight. Schoeneman reported the incident to the police, who set out in search of the wild man. Near Ashmun Hill, the searchers heard growling and discovered footprints heading toward the town of Pickford. Since no further reports appeared in

the papers, and notices of the bazaar's opening referred to the wild man, either authorities recaptured the escapee or Schoeneman picked up a new wild man.

Was the Elks wild man a genuine hairy, manlike monster or just a hoax designed to separate folks from their money? Another sideshow story raises the same question.

WILD MAN IN THE SOO

In October 1903 a story appeared in the *Sault Ste. Marie Evening News* about "a bunch of men" who had gathered in city hall one night to gab. Eventually, the conversation meandered onto the topic of fakery. One of the men recalled an incident many years earlier when a sideshow featuring a purported wild man came to town. The sideshow promoter described the wild man as "ravenously fond of human flesh"; hence, he kept visitors a safe distance away from the wild man's cage. Conveniently, this meant no one got a good enough look at the creature to determine its authenticity. The skeptics among the local population began to speculate that the wild man was nothing but a hoax. With the public's ire rising, the sideshow promoter invited the police to test the authenticity of his exhibit. Authorities brought in two doctors to examine the wild man, aka "bipedicusmaneaticus."

When the doctors approached the creature's cage, it roared and lashed out at them with its teeth. Even a medical

man has his limits, so the pair maintained a reasonable distance between themselves and the cage, forgoing a firsthand examination. After a few moments of conferring, the doctors left the tent that housed the beast's cage. To the crowd awaiting their decision, the doctors announced the wild man was indeed genuine—and genuinely dangerous. Their announcement proved a boon for the sideshow promoter as the crowd surged into the tent, forking over genuine cash to see the genuine monstrosity.

The local marshal was less than convinced. After the furor died down and the crowd dispersed from the tent, the marshal ducked in for a closer look. As the story goes, the promoter winked at the marshal "in a significant manner," inviting the cop to enter the cage if he dared. The animal didn't lunge or snarl at the marshal. The promoter then pointed out the locks of fake hair glued onto the animal, which the marshal could now identify as a raccoon—not a wild man. The story ends with the promoter practically begging the marshal to arrest him for the publicity it would give his show.

The *Evening News* declared the story must be true because the gentleman telling it had a reputation as an honest man. Yet the gentleman telling the tale wasn't present during the marshal's inspection of the creature or, apparently, at the sideshow itself. If his raccoon with hair plugs could fool hundreds or perhaps thousands of people, then the sideshow promoter surely deserved the big bucks people shelled out to him.

DEMENTED WOODSMEN

Some wild men, however, are just that—men gone wild. On Christmas night 1910 the chief of police in Sault Ste. Marie arrested a man the *Evening News* called a "demented woodsman," a fellow from Quebec who jabbered incoherently. Another loon, this time thought to be a Russian, haunted the woods near Kinross around 1904. The sheriff snagged the loony Russian, who spoke little English, and hauled him back to Sault Ste. Marie. From there, he was shipped off to the asylum in Newberry. In 1909 Joseph Krul escaped from the Newberry hospital, allegedly with his wife's help. Some people wondered if Krul was the crazy "Russian" captured several years earlier, but the judge who sent Krul to the Newberry hospital dismissed the idea. The Russian loon had been too short to be Krul.

In October 1901 a disturbed man provided what the *Soo News-Record* called "unappreciated entertainment" for folks living around the city jail in Escanaba. The "raving maniac" alternately cursed at passersby and screamed like a banshee. Police arrested him after he turned up lying partially naked on one of the docks. Once behind bars, he shed his remaining clothing. When asked for his name, the man sometimes replied "Al Moore" and other times answered "Al Parker," but no one in Escanaba recognized the man. Although he initially claimed to live with a wife and twelve children on First Street in Sault Ste. Marie, he later changed his story by turning his wife into a wealthy

heiress living at a spiffy hotel in the Soo. No one in the Soo could vouch for him. The mysterious maniac probably ended up in Newberry with Mr. Krul.

Lest anyone think the turn of the century turned men bonkers, lunatics gone wild made appearances before 1900. Back in September 1887 a "wild man" started lurking around lumber camps along the Yellow Dog River near Marquette. When authorities set out to capture the man, they discovered that an Indian gentleman had already accomplished the task. As the Indian was driving the crazed man toward town at gunpoint, he ran into the cops. The captured lunatic, who had wandered the woods sans clothing, appeared half starved with scratches all over his body from running through the brush. The prisoner claimed that he had escaped from a prison in Colorado and that he had two fathers.

Lunatics, raccoons, lynxes, wild men...who knows what really roamed the woods of the Upper Peninsula back in pioneer days.

Up a Creek...Or a Tree

Even today, the UP boasts miles and miles of uninhabited wilderness reigned over by wildlife. But what happens when the animal kingdom tries to extend its reign to humans?

ALWAYS KEEP A CLUB HANDY

A certain lumberman called Crane was driving through the woods in late November 1902 when he heard a sound no one wants to hear while riding alone and unarmed in a horse-drawn carriage—the eerie sound of wolves growling nearby. Still, Crane didn't worry too much at first. He felt certain a safe distance separated him from the wolves. Crane realized his mistake when one of the wolves ran up alongside the carriage, hurling itself at the horse's nose. The wolf aimed to nab the horse's muzzle, but Crane cracked his whip just in

time. The mare pulling his carriage bolted off down the road at breakneck speed, and the wolf lost its grip. The canine's buddies had other plans, though. The rest of the pack raced up behind the carriage, sending Mr. Crane on a frantic hunt for a weapon to ward off the beasts. Fortune favored the lumberman, and he discovered a large club under the carriage's seat. Crane lashed the club at the wolves until they gave up the chase. The lumberman doubtless armed himself well for any future trips through the woods.

You Can't Take It with You

Since Mr. Crane lived in Daggett, perhaps he bumped into Menominee lumberman Frank Kline. If they met, the two men would've had plenty to talk about. Kline had his own close encounter with a pack of ravenous wolves.

One fall afternoon Kline was driving to work in his wagon, drawn by six horses, with a load of supplies when he heard the ominous howl of a wolf off to his right. He might've felt reasonably secure, until a second wolf replied to the first. The howling rattled Kline's horses, and they upped their pace. Just then, about one hundred feet up the road, a large gray wolf trotted across the track. Spooked by the scent of the wolf, the horses took off down the road at full speed. The wagon bounced up and down, listed side-to-side and jounced over the ruts in the road. The wolves kept howling. The horses kept running. Kline, perched on a

tall seat, clung to his post as the jarring of the wagon swung him to and fro in a twelve-foot arc. While the ride might've pleased a modern teenager used to roller coasters, Kline wanted out of his predicament. Spotting a low-hanging branch up ahead, the lumberman flung himself off his seat and grabbed the tree branch. As he climbed onto a sturdier part of the tree, Kline watched his horses drag the wagon down the road and out of sight.

There, Kline waited out the night, up a tree with wolves all around him below. In the morning, another supply wagon came to his rescue. Kline's horses had gone down a cliff, along with the wagon. One horse suffered a broken leg, but the others survived. Kline mourned the loss of his horse far more than the loss of the supplies, which he found dispersed along a forty-acre stretch of the road.

Back in town, Kline shared the story of his harrowing encounter with a friend who also happened to be a lawyer. Naturally, the lawyer suggested Klein make out a will at once because "when you go into the next world, you can't take it with you." To which Kline replied, "Hell, if I can't take it with me, I won't go!"

The wolves may have had other ideas.

WILD WOLF CHASE

Although today most people consider traps a cruel way of hunting, a century ago traps were a common method

of capturing prey. But in February 1903 one hunter's trap led him on a chase he never expected, after an unusual quarry. Mr. Raymond had set a trap in the woods near Iron Mountain. The next morning, he discovered the trap had disappeared. Spying tracks, Raymond followed them deep into the woods on a trek that took him all day. At the end of his hunt, Raymond hopped over a log—and heard something growling. Looking down, he saw a white wolf huddled against the log with one foot caught in Raymond's trap. To Raymond, the wolf looked huge, almost as large as a bear. The wounded wolf lunged at Raymond, and he dispatched it with a bullet. Raymond acquired his trophy, which turned out to be a more valuable one than he might've dreamed, by killing the first white wolf anyone had seen in the UP.

THE HUNTED HUNTER

Another hunter found himself in a bit of a bind. One day in December 1902 Lake Linden hunter John Franks tromped out into the woods in search of deer. Locating a deer trail that looked well used, Franks headed down the path. A few minutes later he stumbled over what felt like a tree root but, rather than falling face-first into the dirt, he was yanked straight up into the air. A wire encircled his body, holding him in midair ten feet from the ground. A trap set by someone, perhaps another hunter, had snared

Franks instead of its intended quarry, whatever that may have been.

For more than an hour, Franks struggled to free himself from the wire. When he finally succeeded, and felt solid ground beneath his feet again, Franks examined the trap that had swept him off his feet. The unknown trapper had selected a strong maple sapling, bent it over and attached a wire noose to the tree. The noose, which lay on the ground, could be triggered by the slightest touch. Looking at the trap, Franks realized he had been lucky. The noose could have caught him around the neck. The grateful hunter kept the wire as a keepsake and, undoubtedly, as a great prop to use when he retold the tale.

Strange Bear Children

The anger of a wolf wounded by a vicious trap may seem justified. Sometimes, though, animals get testy for other reasons. Consider the case of the mailman and the game warden who went fishing on the Munoscong River in the eastern UP in the fall of 1904. Letter carrier S.J.T. McKinney and Deputy Game Warden John H. Graham set out to hook some trout but ended up getting hooked themselves by a foe the *Soo Evening News* referred to as "strange bear children."

The men dropped off their horse and buggy at a local farm, where the proprietor had agreed to keep it for them.

Graham perhaps took his duties as game warden a bit too seriously. He left his gun behind as well, for fear that someone would think he'd gone hunting for deer rather than fish. His decision to go unarmed may seem a bit stranger still considering that he warned his companion, McKinney, about the dangers of messing with bear cubs.

Nevertheless, the two men took off into the wilds armed with nothing more dangerous than a fish hook.

On the final day of their fishing trip, McKinney found himself separated from Graham by twenty-five to thirty feet of underbrush. When Graham called out to his companion, McKinney trudged through the thick brush toward the vicinity where he had last seen the game warden. Rather than his friend's voice, however, McKinney heard a "woof, woof" noise he presumed was made by some sort of animal. In the spot where he expected to find Graham fishing, he instead spotted his companion shimmying up a poplar tree with two bear cubs nipping at his heels, scratching the bark under his feet as he ascended. The cubs made no effort to scurry up the trunk after the game warden, apparently content to have him treed.

McKinney heard the woofing sound, this time resounding from somewhere in the brush beyond the tree. The mama bear was nearby. Graham's warning about bear cubs must've replayed in McKinney's mind, for he took off in the opposite direction, fleeing until he felt a safe distance now protected him. In the distance, he could hear Graham serenading the bear cubs with popular songs such as "Good Old Summertime." When the concert ended fifteen minutes later, McKinney headed back to the poplar tree. The bear children had left, and the two men jumped right back into their fishing.

A MIDNIGHT SWIM

Sault Ste. Marie is home to the Soo Locks, canals that raise and lower ships so they can pass from Lake Huron to Lake Superior and vice versa. Just after midnight on September 24, 1904, something else tried to make the journey through one of the canals. The men charged with guarding the canal spotted a strange shape surging through the waters. Taking a closer look, they recognized the shape. It was a steer.

The bovine struggled to stay afloat, and the men realized it would drown without assistance as it could not clamber over the canal walls. The steer would swim itself to exhaustion before reaching the canal's end. Since the men couldn't leave their posts, they sent for help. More men rushed to the scene, armed with ropes and life preservers. Someone managed to hook the rope around the steer's horns. The rescuers hauled the animal ashore, but a mystery lingered. How had the steer come to be in the canal in the first place?

No one in town recognized the steer, so the men from the lock took the animal home with them. The mystery of the steer's origins, and how it ended up in the canal, went unsolved.

THE FREAK

Four years later, another animal mystery arose. This time, although everyone knew where the animal had come from, its identity confounded even the experts. A year earlier,

a man hunting near Iroquois Point shot and killed an animal he at first took for a deer. On closer inspection, he wasn't so sure. The hunter gave his catch to one William Monterey. In May 1908 Monterey brought the specimen, now mounted for proper display, to the Belvedere Hotel in Sault Ste. Marie. Most everyone who viewed it agreed it must be some type of deer, though the animal looked quite different from the deer seen throughout the UP. The animal was smaller than a Newfoundland dog and white in color with yellow spots. The creature was deemed not to be an albino due to the normal coloring of its eyes.

The majority of folks who examined the specimen felt it was a fawn with highly unusual coloring. Several people familiar with antelope from the Rocky Mountain region thought the creature in question must bear a closer kinship to the western antelope. If the animal was an antelope, no one could explain how it had arrived in Michigan. No one could offer a definitive solution to the mystery of the four-legged freak.

THE MOST MARVELOUS MARVEL

Some freaks turn up in barnyards rather than woodlands. In October 1910, a farmer from the Soo named Henry Smart announced that he owned a feathered miracle as wondrous, if not more so, as the two-headed calf featured at a recent Elks carnival. He had a three-legged chicken.

According to Smart, the fantastic fowl used its spare leg to steal food from the other chickens. The *Evening News* reported that Smart called his barnyard wonder "the most marvelous of marvels." The farmer hoped to enter his tripod hen in the next year's fair, presumably in the three-legged race.

Inland Sea Serpents

Another freak of nature may or may not exist. Tales of sea serpents date back hundreds, perhaps thousands, of years and span the globe. While the most famous serpentlike creature reputedly swims the waters of Loch Ness in Scotland, the UP is not immune. Three of the Great Lakes border on the UP—Superior, Michigan and Huron—and all three have had reports of sea serpents. Since each of the Great Lakes, particularly Lake Superior, is large enough to qualify as an inland sea, maybe inland sea serpents is a better name for the mysterious creatures.

In the late nineteenth century, a sea serpent made appearances around Mackinac Island in Lake Huron. A strange creature was even sighted in Au Train Lake, a body of water connected to Lake Superior only by a circuitous river route. In the latter part of the nineteenth century, two brothers canoeing on Au Train Lake watched the creature circle around their canoe, its teeth chattering. One of the brothers smacked the creature with a paddle, and it sank to the bottom.

In August 1895 Captain George Robarge of the steamer *Curry* saw something he could not explain while steaming across Lake Superior. Near Whitefish Point the captain, along with his second mate and watchman, saw an unknown beast raise its long neck out of the water four hundred yards away from the *Curry*. The creature kept pace with the ship for five minutes. The three men studied the creature through a spyglass, gaining a good look at it. They estimated that the neck was fifteen feet long and that the creature could open its jaws at least a foot apart. The body, which they got glimpses of, seemed to undulate. Finally, the creature vanished under the waves.

That same year, on July 4, a Menominee resident spotted a serpent on Lake Michigan. The *Ironwood News-Record* dismissed the sighting because "the beast was seen on the Fourth by a watchmaker." A year later the former state fish commissioner, Eugene G. Blackford, told the *New York Times* he believed in sea serpents, partially. He stated he believed "there are huge marine monsters which appear like serpents" and trigger the sightings reported. When asked why no such creatures had washed ashore, Blackford explained that they probably live deep in the sea, and carcasses of deep-dwelling creatures rarely wash ashore.

In March 1905, the *Evening News* out of Sault Ste. Marie recounted a series of events from years earlier that occurred along the St. Mary's River, which separates the Michigan and Canadian sides of the city. The river also joins Lake Superior to Lake Huron. A tugboat called the

Flora Holden was motoring from Hay Point down the river when crewmen spotted a huge serpent slithering through the water about a half mile away, its tail thrashing the water into a foam. Rowboats dotted the river, their occupants apparently unaware of the monster nearby. The captain of the *Flora Holden* shouted at the rowboat occupants to "git out of the way" before they got "swallered whole" by the serpent. All the boaters raced to shore.

Over the following week, the serpent chased the *Flora Holden* three times. Pleasure seekers stopped renting boats. Two "prominent citizens" reported seeing the serpent sunbathing near Sugar Island. Witnesses told of the great beast munching on shrubbery in Pleasant Park, hurling water forty feet in the air when it shook its tail to chase away a crane and snapping the rudder off a tow barge. Yet, as with most tales of the paranormal, a claim of hoaxing cropped up and became readily accepted—at least by the

media. The story goes that the crew of the *Flora Holden* fashioned a fake serpent head out of a beer keg, attaching to it a hose several hundred feet long. The crewmen then attached a half-mile length of wire to the hose and used the wire to drag the contraption through the water. The revelation of a hoax soothed the nerves of the pleasure seekers, who once again rented rowboats. Did the hoax story germinate out of truth or out of financial need? A beer-keg head might explain the waterborne sightings. But with the land-based behavior reported by witnesses, a beer keg seems an unlikely suspect. The whole truth of the incidents may never be known.

Sometimes, though, the truth is obvious. In July 1904 the *Sault Ste. Marie Evening News* retold an old tale recounted by saloonkeeper John Quinn. Years earlier, Quinn had worked as a diver salvaging shipwrecks. One day, Quinn was working on a wreck off the coast of Mackinac Island, waiting for his pumps to kick in and lift the wreck off the bottom. Having heard tales of sea serpents before, his mind wandered onto the topic. Just as the hull of the ship raised off the bottom, a writhing body came into view beneath it. The creature darted straight toward Quinn. He swung his sledge at the beast and smacked it in the head. The creature whacked him back with its tail. Quinn fell over backward but, as he righted himself, he got a better look at the beast that had taken him by surprise. It was a sturgeon.

The Lost and the Found

A century ago, the forests of the UP remained mostly unexplored—and mostly uninhabited. Residents of the rest of Michigan viewed the UP as a dark backwater brimming with danger. Only the foolhardy folk who worked the mines and lumbered the woods dared venture into the unknown realms north of the Straits of Mackinac, or so thought the rest of Michigan. But sometimes the phantom dangers became all too real. The first recorded disappearance happened in the late seventeenth century, when Father René Menard, the renowned Jesuit missionary, set off into the woods of the Keweenaw Peninsula—and was never seen again. He would not be the last person to vanish in the UP.

FOOTPRINTS AND A HAT

On December 7, 1887, a mystery surfaced on the St. Mary's River in Sault Ste. Marie. A hat was found bobbing in the waters. Intrigued by the hat, locals gathered at the waterfront. They soon discovered a series of footprints approaching a dock, tracks that ended at an area of disturbed snow right at the water's edge. Some of the snow, which had newly fallen, had been knocked off into the water. Since no footprints led away from the water, the onlookers surmised that someone had fallen off the dock, though they found no evidence to suggest whether the fall happened by accident or as part of a suicide. Crewmen from the ferry *Beckwith* hooked the hat with a pole, rescuing it from the waters. The hat was a derby from Chicago, pale in color. Its owner was never found.

A CLUB AND DYNAMITE

Water would also prove deadly for Alfred Anderson of Cedar River. On October 23, 1902, Anderson vanished. No clues were found to suggest how or to where he disappeared, although Anderson's roommate became a suspect for awhile. In November a new witness, August Holman, told authorities he'd seen a mysterious man wielding a club. The man was hurrying across a tall tramway over the river. Despite the fact Holden neither

got a good look at the mystery man nor saw Alfred Anderson, the sighting bolstered the hypothesis that the missing man had met a violent death. Authorities dragged, and even dynamited, the river in search of Anderson's body. No sign of Anderson turned up—not even his hat.

Swallowed Whole

On May 2, 1901, William Sweet was manning his station at the lighthouse alongside the canals in Sault Ste. Marie when he spotted a small boat heading into the Soo Rapids. Knowing the boat and its two passengers would meet certain doom there, Sweet thought to dash out and warn the passengers. Before he could move, the boat dove into the rapids and was sucked under the bridge connecting the Michigan and Canadian Soos. A moment later, the boat was spit out the other side. The passengers clung to the little rowboat until it capsized. Sweet saw no more of the passengers.

The terrible incident led to a mystery. Who were the passengers, apparently young boys? Authorities thought they might've come from the west side of the Michigan Soo, but no one had been reported missing. The rapids swallowed their identities as well as their bodies.

Nature Girl

In October 1862 a young woman named Mary Sullivan vanished on the Keweenaw Peninsula. Mary worked in the home of a family living near Houghton. One night she shed all her clothes, grabbed a shawl and snuck out of the house without anyone noticing. A two-day search netted no evidence of her whereabouts, but folks speculated that sleepwalking or insanity drove her out into the woods. The mystery only deepened ten days later. A member of the search party, who refused to give up even after everyone else did, found Mary strolling through the forest. She carried a stick over one shoulder and was still naked, save for the shawl draped over her shoulders. Despite ten days in the woods without food or a thread of real clothing, the young woman looked in good shape, as healthy as the night she disappeared. Her only visible injuries were cuts to her feet, though she also had a cold.

During her time in the woods au naturel, a significant amount of snow had fallen, and each night brought a hard frost, yet Mary seemed oblivious to the harsh conditions. After evaluating the young woman, authorities deemed her insane. While her mental state may explain why she took off in the middle of the night sans clothing, no one could explain how she survived ten days alone in the woods with only minor injuries.

Sick in the Brain

On June 16, 1887, a corpse surfaced on the St. Mary's River in Sault Ste. Marie. After retrieving the body from the water, authorities examined it and identified the remains as belonging to Thomas Wigwaus. The investigation revealed that Wigwaus had disappeared from Sugar Island, southeast of the city. No one had seen the man for quite some time. On the afternoon of the day the body was found, an inquest was held to determine the cause of death. According to the *Sault Ste. Marie Democrat*, authorities decided that "the deceased's brain was affected," causing him to wander straight off the end of a pier "in a fit of temporary insanity." The inquest jury concurred.

Since no one saw Wigwaus on or off the pier, the decision perhaps makes the coroner and the jury sound a bit "affected."

A Blind Pig in Fire Water

In 1919 the United States ratified the Eighteenth Amendment, prohibiting the manufacture and sale of alcohol. A story from the Keweenaw Peninsula may shed some light on why the states wanted Prohibition—and why the Indians called alcohol "fire water."

A blind old man called Moses Obimigijig and his wife spent their time traveling through the towns that cropped

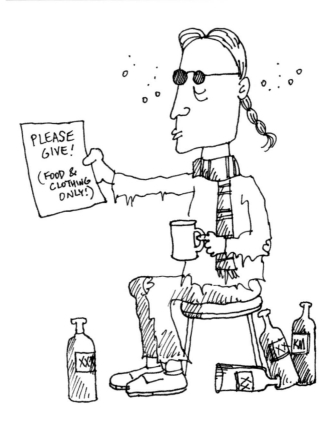

up around the various mines. Moses made his living through begging on the streets. To anyone who passed by, he would offer a letter—written and rewritten by whatever anonymous stranger he could convince to do so—explaining his condition and asking for the passerby's charity. The tactic seemed to work for Moses. Eventually, however, Moses began

to drink so much that one of the kind souls who recopied his letter for him felt compelled to include a postscript in the note. The addendum warned readers of Moses's drinking problem and advised them to give the blind man only food or clothing, not money. The unwitting Moses proffered the letter to passersby, who heeded its advice. The old couple, neither of whom could read, had no idea why their earnings plummeted. Then one day, a friend told them. Shortly thereafter, Moses found another charitable hand to rewrite the note, without the postscript.

Not long after, on July 4, Moses and his wife vanished. Their rowboat turned up on Portage Lake, partially flooded, with a half-empty keg of beer as its only occupant. Days later, the body of Moses's wife washed ashore near Bootjack, and a week later, Moses's body was found at the mouth of the Sturgeon River.

But the story continues. Four of Moses's relatives, including a chief, took it upon themselves to find out where the blind man had gotten his beer. Their alleged aim was to have the supplier arrested, since they blamed said supplier for Moses's death. They ended up at the homestead of one John Sky, a man with a reputation for knowing where to find booze, aka "blind pig."

On the night in question, Sky knew precisely where to find such a blind pig, half a mile away. He had one problem, though. His booze connection demanded cash, and he had none. Realizing he could get no pigs without bucks, Sky encouraged his cash-bearing visitors to fund the

bender. They waited until sunset before setting off across the Portage River to the residence of the blind pig dealer. Sky knew how to find the secret door, through which they obtained their liquor. Moses's relatives, who claimed to seek justice, instead sought refuge in a jug of moonshine.

Apparently, the lesson of Moses's death flew right over the heads of his kinsmen. After ditching Sky, the quartet climbed into the boat and set off down the Portage River into Keweenaw Bay, on Lake Superior. A fierce wind kicked up out on the lake. Intoxication and high winds don't mix well, and their boat capsized. The bodies of two of the men were found naked, as if they shed their clothes in the hopes of swimming better in the buff.

Moses got burned by fire water, while a blind pig doomed the blind man's relatives.

BLIND IN THE EARS

Blindness explains why Moses didn't realize someone had changed his panhandling note. But in another case, when authorities offered vision problems as an explanation for a death, they forgot one little thing: people have ears.

On the evening of November 26, 1902, Leon Tebear left his home in Clarksburg, west of Marquette, to spend a day in Ishpeming. At four o'clock, he left Ishpeming on the train, traveling with another man, heading westward again to Humboldt. There, Tebear hung out until after seven, at

which time he set out for home on foot. No one would see him alive again.

The next morning Tebear's body, lifeless as a hunk of copper, turned up alongside a railroad track between Humboldt and his home in Clarksburg. The mysteries mounted as the authorities investigated the circumstances of his death. The sole marks on his body were a pair of bruises on his hip and back, which seemed unlikely to have killed him. Also, Tebear always took the county road home. But on the night he died, he chose a route that followed the railroad tracks instead. Although no one could explain why Tebear took a different route home, authorities managed to dream up a theory to explain his death. Since Tebear had been in ill health, authorities surmised he died of exposure after a train hit him and flung him off the tracks. The theory assumed that the impact, despite leaving only two bruises on Tebear's body, injured him so badly that he couldn't get up on his own.

Why didn't Tebear get out of the train's way? Because extreme nearsightedness rendered him nearly blind. According to the official theory, Tebear had trouble finding his way home in daylight, much less in the dark. Yet authorities failed to explain why he didn't hear the train coming. Tebear must've been blind in the ears as well as the eyes.

Flying Fists and Sharp Tongues

In the nineteenth century, the Upper Peninsula was a no man's land populated chiefly by the rough types who worked the mines and lumbered the forests. Many of the workers, especially in the mines, were immigrants. Today we tend to think of nineteenth-century America as a melting pot of cultures, a vision that has become idealized in our minds. Here in the UP, things could get a little rowdy—and the melting pot sometimes boiled over onto the streets.

COPPER COUNTRY COMBAT

Immigrants of Cornish and Irish descent made up the majority of the workers in the copper mines around

Hancock, including the Quincy Mine. Despite hailing from the United Kingdom, the miners presented anything but a united and peaceful front. Brawls were common and were often reported in the local newspapers.

On August 9, 1862, a Saturday night out on the town turned into a brawl between a couple of Irishmen. When a police officer tried to arrest the aggressor, a mob of over one hundred Irishmen thwarted his attempt to bolster law and order. Someone sent for the sheriff. When he arrived, the sheriff instantly grabbed the man in question—only to find himself besieged by the same crowd who had blocked the officer. But it takes more than a mob of belligerent Irishmen to stop the sheriff of an unruly mining town. After transferring his prisoner to the custody of the officer, the sheriff took on the worst of the lot, sentencing a dozen of them to kiss the dirt. Meanwhile, the sneakier Irishmen seized the opportunity to assault the officer who had made the original arrest. The beleaguered cop came out on the bottom, literally, chucked to the ground half naked. When the sheriff took off after the assailants, the Irishmen pelted him with a fusillade of rocks. The sheriff shot back—with bullets. Not even gunfire could deter the angry Irishmen, though. The sheriff had to concede defeat.

Peace did not reign on the Sunday before Christmas of that year either. On December 21, at the house of a German man, Cornishmen and Irishmen congregated—but not to share a beer and a Cornish pasty (meat pie). At 10:00 p.m.

the Cornishmen locked the door, trapping the Irishmen inside the house with them. Outnumbered, the Irishmen wound up taking quite a beating from the pasty lovers who, according to the *Houghton Mining Gazette*, "shamefully maltreated" the lads from the Emerald Isle and left one's face "cut and pounded almost to a jelly." In the midst of the battle, one Irishman managed to slip out, perhaps through a window, to gather reinforcements. By the time the Irish mob arrived, all but one of the Cornishmen had fled the scene. The unlucky gent left behind, who had watched the festivities while enjoying a cigarette but refrained from participating, suffered the wrath of the Irish. While he might've preferred to receive the luck of the Irish instead, the poor Cornishman endured less of a beating than the Irishmen had, as the cops showed up just in time to save him. Maybe a leprechaun had blessed him after all.

The following Friday, the uncivil war between the Irish and Cornish exploded once again. A flurry of rows bloodied the sidewalks on both sides of Portage Lake. On the Houghton side, a man was shot twice, leaving him in critical condition. Over in Hancock, a Scotsman somehow got swept up in the battle between Ireland and Cornwall. The Scotsman was stabbed several times, so brutally that his innards spilled out of his gut. Although police knew where to place the blame in general, on the Irish and Cornish men, they couldn't identify the specific perpetrators. The authorities made no arrests.

FAMILY FEUD

Maybe violence is contagious. On Christmas Eve 1862, smack in the middle of the Irish-Cornish battles of the same week, passions got the better of the Sullivan family, who lived at the Columbian location near Hancock. The Sullivans felt they had acquired enough wealth and influence to brag about it, so they held a little conference at their home to hash out the details of who should get the credit for the family's successes. Trouble was, everyone wanted credit and no one wanted to share. In an average family, the yelling might segue into pounding fists on the table. In the Sullivan family, however, kinsmen pounded their fists not on tables but on each other's heads. The fracas ended with three family members, two men and a woman, severely injured and the rest behind bars. And not the kind of bars that serve drinks.

WAR IS HELL

The Civil War was so bloody that the armies on both sides needed every able-bodied man to serve in order to replenish the ranks. Men who refused to enlist were labeled cowards at best and traitors at worst. On the Keweenaw Peninsula, tensions already simmered between the various ethnic groups who came to work in the mines. Stir in wartime stresses and the concoction became volatile.

In August 1862 the cantankerous miners got wind of two "weak-kneed patriots," as the *Mining Gazette* dubbed them, who were cowering in a barn near Houghton because they feared getting drafted. The man asked to keep watch for them instead told the miners, who told everybody they knew, and all gathered outside the barn to teach the lily-livered pair a lesson. One of the crowd, who fancied himself a marshal, commanded the duo to exit the barn and submit to enlistment. The two men inside the barn found themselves trapped in a microcosm of the great war raging nationwide. Doing what came naturally, they crawled out a window and fled into the woods. Unfortunately for the duo, the crowd spotted them making their escape. Everyone rushed after them, "firing pistols and stones and yelling like Indians," as the *Mining Gazette* described it, all the while demanding the two men turn around to face their accusers. But the pair would have none of it. They disappeared into the woods.

One of the men showed himself briefly a few days later. He had lost track of his buddy and assumed he'd been shot dead.

RAILS AND ROWS

Before the era of unionization, nothing restrained employers from dealing with labor strikes in whatever manner they saw fit. So when 120 railroad workers in

Baraga County threw down their tools in revolt against F.G. O'Reilly & Co. in April 1887, they got an unexpected response to their demands.

The workers—who were Italian immigrants, known less than affectionately as "dagos"—asked for a bit more than their employers wanted to give. The *Marquette Daily Mining Journal* reported that the workers "requested the contractors to hand over the earth with a blue ribbon tied around it." The company called in the sheriff. Soon, the workers found themselves hauled off to the train station by the sheriff and his deputies. At the station, they were lined up to board a train for the first leg of a journey back to their homeland. Suddenly, conditions back at the railroad camp looked a lot better to the laborers. Harboring no desire to go home again, the workers shuffled back to the camp at Nestoria. Work resumed on the tracks for the iron horse, which would soon run through the hinterlands of the UP.

FIRST-CLASS FISTICUFFS

Less than a year later, in August 1888, the Italian railroad workers caused another ruckus. Some forty or fifty Italian boys invaded the Nestoria station to climb aboard a train bound for Marquette. The boys crammed into the smoking car, disrupting the peace and quiet of a thundering locomotive with their rambunctiousness. At some point during the trip, the Italians got bored of hanging out in

the smoking car and decided first class looked much more appealing. They bolted for the first class car but the train's brakeman, Mr. Jones, blocked their path. There were ladies in first class, after all, whose honor Mr. Jones took it upon himself to defend. A battle ensued, pitting the self-appointed knight against the Italian dragons.

The result? The Italian boys smashed Jones's head through the door to the first class car. Jones snatched up a stove shaker, an iron tool for stoking a fire. He cracked it over the heads of several Italians, ending the battle. Once again, the Italian boys retreated in defeat.

The ladies in first class may have breathed a little easier, provided they weren't wearing corsets.

SOO SQUABBLES

On weekends in the fall of 1887, Portage Avenue in Sault Ste. Marie could turn into a boxing ring. September 18, a Sunday afternoon, proved a violent Sabbath. Two men got into a vicious argument on the avenue, at first shouting and then punching each other in what the *Soo Democrat* described as "the latest pugilistic fashion." A certain Officer Fickie intervened. As he escorted them to the police station, Fickie learned the facts behind the men's disagreement. Their fight had its origins in a most politically incorrect exchange between the two men. When one man had announced proudly that he came from Canadian stock, the

other man snapped back that his blood was pure American Yankee. Canadian blood was, to paraphrase the fellow more politely, undesirable. Naturally, slugging had ensued.

A couple blocks into their trek to the station, perhaps riled up by recounting their argument, the men started jabbing their fists at each other again. Officer Fickie broke up the fight for a second time and rushed the men into the station to deposit them safely behind bars. Sault Ste. Marie may straddle an international border but, judging by the behavior of the two men in question, not all the residents of the area want to bridge that line.

A cop would rush to Portage Avenue again on October 15, a Saturday night, when two ungentlemanly gents called McDonald and McGrumley had a misunderstanding that escalated into shouting and cursing. The argument got so loud and rancorous that a policeman interceded, threatening to send both men to the cooler. Neither McDonald nor McGrumley wanted to experience the hospitality of the police department. The policeman, an officer named O'Neil, insisted. According to the *Daily News-Record*, McDonald and McGrumley "forcibly demurred" to O'Neil's wishes, letting the officer shepherd them to the police station for a weekend getaway in a steel-barred suite.

On Monday morning, both men paid their fines—ten dollars for McDonald, five dollars for McGrumley—plus court costs to free themselves.

NEW YEAR'S KNIVES

Words may not hit as hard as sticks and stones, but sometimes the object of an insult reacts as if the words struck him like a blunt object to the head. In January 1897 Nicolas Blick of Hancock felt the sting of mockery hurled at him by a drunken man. When the drunkard refused to apologize, Blick tackled him to the ground. The two men who accompanied the drunk did nothing to stop the fight, apparently content to watch the show from their first-row seats. No apology followed as the drunken man clambered to his feet, so Blick jumped him yet again. This time the two men wrestled, and the drunk managed to pull out a knife. The unknown man stabbed Blick twice before he leaped up, fleeing with his buddies. Blick suffered a deep wound to his gut and a minor wound to his chest, with his rib blocking the knife from slicing into his heart. The gut wound was expected to heal without complications.

Blick told the police that both the drunk and his buddies looked like Austrians and spoke with accents. Just how Blick could distinguish Austrians from, say, Germans by looks alone remains a mystery. In spite of Blick's explicit description, the police didn't know which Austrians to arrest, since the only clue left behind by the assailant was a blue hat.

The Man from Ire-Land

Back in the nineteenth century, the Irishmen of Houghton County often took the first syllable of their homeland's name too literally. Their ire could get roused by the darndest things, like courtroom discourse. The proliferation of lawyer jokes attests to our cultural fascination with hating members of the legal profession, but one resident of the old-time Copper Country took his disdain a few steps further.

In March 1863 Mr. Sennett, a man from the aforementioned country, sat in the county courtroom observing the proceedings. Something one of the legal men said must've rubbed Sennett the wrong way, for he exclaimed his displeasure with the lawyer's words in rather impolite terms. The sheriff ordered Sennett out of the room. Sennett proclaimed that neither the sheriff nor anyone else in the courtroom had the authority to boss him around, no matter what he chose to say or do. When the sheriff threatened to arrest Sennett, the Irishman hurled himself at the sheriff. By the time the scuffle ended, Sennett lay spread-eagled on the floor with the sheriff towering over him and, a short while later, the Irishman had his pick of cells at the jail.

To discourage Sennett's countrymen, or anyone else inclined to mimic the Irishman's outburst, the judge increased the fine for such behavior to a whopping ten dollars.

Tales of the Rails

Railroads changed the face of the entire country, including the UP. In 1839, the first railroad came to the Upper Peninsula, and thereafter locomotives played an integral role in the history of the region. Stories of heroic rail workers and harrowing accidents abound, but other stories from the tracks demonstrate the true and unique character of the UP.

THE WHATSIT

Train engineers got used to seeing all kinds of things on the tracks, from animals to people. Yet even a seasoned engineer could be caught off guard. On June 27, 1891, the man at the helm of the eastbound train heading toward Nestoria, west of Marquette, caught sight of an object on the tracks ahead. Was it a cow? The twilight of early

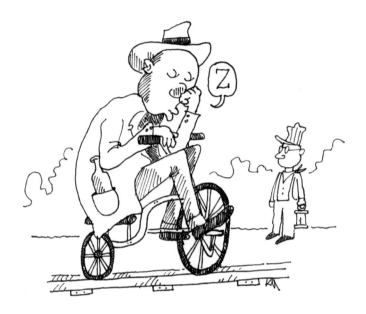

morning obscured his view, so the engineer assumed the object was just a cow and naturally plowed right over it. After all, who cares if the UP has one less cow? The instant the train hit the object, though, the engineer realized he'd made a horrible mistake.

His first clue came when a man scrambled out of the ditch alongside the tracks shouting, as the *L'Anse Sentinel* put it, "theological remarks"—most likely directions for how the engineer could reach a certain fiery locale referred to in the Bible. The man had been riding a homemade contraption, a kind of tricycle designed to run on the railroad tracks, when he fell asleep. Perhaps the old blind pig had a hand

in matters. Whatever the cause of his narcolepsy, the man seemed "not particularly damaged," by the *Sentinel*'s account, and the engineer gave him a ride to the Nestoria station. The railroad company took possession of the man's tricycle for "inspection."

A STEP TOO FAR

The ladies of the Victorian era adhered to strict standards of behavior imposed on them by society, and they expected men to do the same. Someone should've given an etiquette manual to the train conductor who worked at a station a few miles from Ishpeming, for he clearly had no clue. One day in September 1889, as the train pulled into the station, it stopped just past the mark with its platforms misaligned. Passengers had to hop down off the station platforms and then hop back up onto the train's steps in order to board. A young woman saw this as unladylike behavior and, unwilling to breach etiquette, stubbornly refused to make the leap. The conductor proved as stubborn as the woman, refusing to back up the train for her. The ungentlemanly conductor and the prim lady could not reach a compromise, since neither would concede even a millimeter to the other. Finally, the conductor called "all aboard" twice and gave the signal for the train to leave the station.

The young lady walked home to Ishpeming.

A HIGH PRICE FOR BOREDOM

Working on the railroads must've gotten tedious at times. Combine boredom with the tough-guy personalities of the young men who worked the railroads, and labor was bound to turn to mischief on occasion. In December 1892 the boys working on the rails south of Ishpeming wound up costing themselves some of their hard-earned money through a prank. They stole a dummy from a local clothing store, dressed it up in a suit and tie and placed it in the bed of an operator who worked at the South Ishpeming station. When the operator climbed into bed that night to find he was not alone, he figured one of the rascally rail workers had snuck into his bed as a practical joke. Choosing to play along, the operator tried to rouse the prankster. Soon he realized his bedmate was rather stiff, with skin as rough as plaster. Realizing what had happened, the operator removed the plaster dummy from his bed and smashed it to bits. As an unexpected bonus, in destroying the dummy, he also got a measure of revenge on the pranksters.

The boys who planted the dummy in the operator's bed had to pay the owner of the clothing store for the demolished dummy.

LUCKY BREAK

Unlike the railroad workers who manufactured their own misfortune, a man in Sault Ste. Marie met good luck on the

tracks back in January 1901. The fellow was walking across the station platform toward a truck that sat on the ground a few feet from the platform and tracks. As the man stepped off the platform onto the ground in front of the truck, the train roared into the station. The locomotive bashed into the man, hitting him in the shoulder and bowling him over. Luckily the driver of the truck saw what was happening and quickly backed his vehicle out of the way to give the man somewhere to go other than the tracks. If the truck driver hadn't reacted quickly, the man would likely have fallen onto the tracks right underneath the train. Even luckier for the fellow in question, he got up again with nothing more than scrapes and bruises.

PLOWED OVER

Getting run over isn't always a bad thing, at least for one conductor at a freight depot in the Soo. Back in January 1888 the aforementioned conductor, David Bailey, nearly fell under the wheels of a train at four thirty one afternoon. He was sprinting down the tracks in front of a train when he tripped in a hole, lost his footing and fell. As the train thundered toward him, he struggled to get up off the tracks, but the engine came too fast. The engineer couldn't stop the train fast enough, and the engine struck the conductor. All seemed lost.

The engine, however, had a snowplow attached to its front. The plow scooped up the conductor and slid him

down the tracks a ways before dumping him off the side. When the engineer realized what had happened, he swiftly reversed the engine. Bailey, though badly injured, suffered no broken bones and was expected to recover fully. If the plow had been set a little higher, it would've missed Bailey, and the train's wheels would've crushed him. Getting run over by the snowplow saved his life.

THE WANDERING BOXCAR

Someone has to keep track of the boxcars at a rail yard to make sure they wind up in the right place. In the Marquette area, a man charged with this duty happened upon a mystery in March 1890. Boxcar 1458 had disappeared. He tracked the car back to a railroad station but could find no trace of it there. The man decided to play Sherlock Holmes, intent on finding the missing boxcar no matter how long it took. From the station where the boxcar was last seen, he headed out onto the tracks in search of the itinerant car. Just north of Ishpeming, he turned off the main tracks and onto a line that led to a small mine, a track not kept open over the winter months. The man had traveled a mile down the track when he spotted a large object up ahead, an object that looked strangely familiar to him. It was a boxcar.

As he approached the car, he discovered it wasn't just any boxcar but was, in fact, the errant car 1458. At least now he knew where the car had gone. An inspection of

the car cleared up the rest of the mystery—a farmer had apparently stolen the car for use as a horse barn. When the boxcar accountant found the car, he also found six horses lounging inside their appropriated accommodations. The car was repossessed, and the farmer was forced to consider building an actual barn.

A NEAR DEATH EXPERIENCE

A runaway train is the worst nightmare of any railroad engineer. If a train full of passengers goes out of control, the terror can end in unspeakable carnage, yet even a runaway freight train can result in catastrophe. The quick thinking and bravery of railroad employees, however, can change the ending.

In May 1894 a train packed with over one hundred passengers sat at the station just outside Ironwood awaiting its departure time. At the same time, a few miles to the east at the Aurora Mine, a line of ore cars bearing iron from the mine broke loose. The ore cars barreled down the hill straight toward the passenger train—but no one on that train knew of the oncoming danger. As the ore cars ripped past the Ironwood station, the yardmaster tried to jump onto the cars. He hoped to slam on the brakes, but instead he was flung off and wound up sailing through the air. Just when tragedy seemed inevitable, a railroad agent named Brig Shove leaped into action. Shove raced to the

telegraph operator, thrust him aside and quickly tapped out a message to the station where the passenger train waited: "Limited depart for Ashland at once. Runaway train. Death threatens you."

Receiving the message, the passenger train hustled out of the station seconds ahead of the ore cars. The runaway cars smashed into another train whose passengers were about to board. The crash wrecked two coach cars and hurled the engine off the tracks, but no one was injured or killed. When push came to Brig Shove, the railroad agent sprang to the rescue, saving hundreds of lives.

THE DEMON TRAIN

Hundreds of lives teetered on the brink of disaster yet again on February 16, 1888. When residents of Marquette heard the shrieking of a runaway train barreling toward their city from the Keweenaw copper mines at seven thirty that night, panic gripped the townsfolk. Everyone expected disaster, but no one could've predicted the events that unfolded next. The *Mining Journal* described the scene:

> *Nearer and nearer came the long shrill shrieks, rising higher and higher in pitch and louder and louder, until the very air seemed to quiver in sympathy, and almost human agony seemed expressed in the wild danger signal which a brave engineer and fireman, facing*

*almost certain death themselves, were sending ahead to
warn men along the road and to clear the main line for
the mad rushing train.*

As the train hurtled through Marquette, its wheels spewed fire. The friction of the rails against the wheels, with the brakes clamped on them, spawned sparks that transformed the iron horse into a flaming demon stampeding straight out of hell. The flames from the locomotive lit up the winter night. The train rocketed past Front Street station and out of sight behind buildings, heading for a series of sharp curves on the east side of town. Onlookers held their breaths in anticipation of the horrendous crash that would surely signal the end of the train's run and death for the engineer and his crew.

Instead, silence enveloped the town.

Everyone rushed toward the Superior Street depot. The train, once a runaway demon, sat peacefully parked at the depot in the exact spot where passenger trains pull in to let travelers disembark and board. James Ahearn, the train's engineer, hopped out of the engine as if he had just completed another mundane trip from the mine rather than a bobsled race through Lucifer's kingdom. Both the engineer and the fireman told the crowd they had never expected to step off the train alive. They felt certain they would end their days at the bottom of Lake Superior, since they knew that upon hitting the first sharp curve the train would surely fly off the tracks into the lake. One brakeman

had held his post as long as safely possible, jumping from the train after it passed Fourth Street. A snowdrift broke his fall. The other brakeman survived by unhooking the caboose in which he rode. Only the engineer and fireman hung on for the entire ride. But what had stopped the train?

As the train rounded a small curve between Third Street and the Superior Street depot, it began to splinter. The force of the runaway train hurled its cars in all directions. Several cars packed with timbers, intended for use in the construction of a new ore dock in Marquette, spilled their loads. The timbers lodged under the wheels of one of the boxcars, creating enough drag to slow and finally stop the train. By a strange coincidence the engine rolled to a halt precisely lined up with the passenger platform at the depot.

The timber missiles destroyed two buildings as well. The boxcars brimming with copper jackknifed across the tracks or flipped up onto flatbed cars that carried timber. The train missed Lake Superior by a mere three hundred feet. One of the timber cars stopped just short of demolishing a boardinghouse, and one of its timbers struck and killed a dog. The canine would be the sole casualty. Although five days later debris from the wreck still choked Superior Street, not a single human being had perished or suffered serious injury as a result of the accident.

Ripped Off

S ome people want what everyone else has and aren't content to wait until they've earned it themselves. They flout the law to snatch whatever they can take. In the early days of life in the UP, just as today, the law looked unkindly on thieves—but legal disapproval hardly deterred them.

Burglariously Burgled

To one would-be thief, the train depot at Humboldt screamed "rob me." In the last week of April 1888, said thief broke into—or, as the *Negaunee Iron Herald* phrased it, "burglariously entered"—the ticket office late one night hoping to cash in without clocking in any hours of work. The thief pilfered a few train tickets, but the money drawer was empty. Perhaps he should've practiced his burglarious skills before undertaking the heist. After snapping the knob

off a safe owned by the American Express Company, the burglar gave up, probably because he lacked the skills to open the safe. Unbeknownst to him, he had capitulated within inches of clenching his hot hands around a $500 wad of cold, hard cash. As he fled the scene, squeezing out a window, the thief somehow lost a bit of his clothing. Just to prove his luck had thoroughly deserted him, when he exited the depot he left behind what the newspaper would call "the dimensions of a peculiar foot" in the snow beneath the window. Due to the strange footprint, police foresaw no troubles in locating the thief.

AN ORIGINAL SIN

Other thieves do hone their skills, seeking new and better ways to rip off hardworking folks. Sometimes crime does pay, especially when the criminals get inventive, as a team of burglars did in November 1902. The thieves had set their sights on the jewelry display window at the D.K. Moses & Co. store in Sault Ste. Marie. The obvious method of snatching the desired items would be to smash the window, grab as much as they could and run. But no, these thieves craved a more sophisticated approach. The display window featured one-inch holes drilled in its sash to admit cold air, with the aim of preventing the window from frosting over in the wintertime. The sash holes provided the opening the thieves needed, both literally and figuratively.

First, the burglars obtained a long metal spike. Next, they threaded the spike through one of the sash holes, snagged some jewelry on it and pulled the items out through the hole. They repeated the process countless times, until their spike got caught on the bunting that lined the inside of the display window. The fabric clogged the hole. They could've unclogged the hole or chosen another of the many sash holes through which to continue their heist. Something must've scared them off, however, as they abandoned the window without finishing the job. The next morning, store workers found the spike lodged in one of the sash holes, along with the bunting. Several rings lay scattered over the sidewalk outside the window. Although they bungled the ending, the thieves got away with enough gold jewelry to make the stunt well worth their while. The burglary also cemented the thieves' reputation as one of the most original teams of burglars in the UP.

KEEPING THEIR MCCOOL

Thomas McCool and his wife lived near the schoolhouse in Sault Ste. Marie. At three o'clock one morning in October 1887, strange noises coming from downstairs woke them. Mr. McCool ventured down the staircase to check out the goings-on in the lower level. There he found a drunkard staggering about, rifling through the McCools'

possessions, apparently looking for something but having no luck finding it. McCool demanded to know what the intruder wanted. The drunkard mumbled something about wanting to find the principal of the school. McCool let the intruder know, in the most direct manner possible, that he had come to the wrong address. The homeowner tossed the prowler out on his keister.

What the intruder wanted with the principal, or how he thought he'd find the principal in the drawers at the McCool house, remains a mystery. The incident

convinced Thomas McCool he needed to protect himself and his wife with something more definitive than words. He purchased a revolver, which he and his wife practiced with every day thereafter.

BAD TIMING

Some thieves would do well to watch their backs when making their escapes. An Escanaba burglar learned that lesson the hard way in October 1910. After breaking into the home of Henry Montigny, the thief probably thought he had plenty of time to hunt around for goodies. Mrs. Montigny, hearing noises, went to investigate. When she caught sight of the thief, the lady let out a bloodcurdling scream. The thief hightailed it out of the house, but not before dropping his pocket watch on the ground outside the window. The police got the watch, while the thief fled before finding any of the goodies he so craved.

CANADIAN BUTTER

While a desperate thief will take whatever he can find, if his booty is too unusual he may have trouble unloading it. In November 1902 Jerry Nerburne got himself into just such a mess. Clad in sailor's clothes, Nerburne waltzed into a saloon in the Soo one evening lugging a crate of butter. He tried to

offload his freight for the bargain-basement price of three dollars, but no one would take him up on the offer. Leaving the saloon, Nerburne went in search of another buyer. Instead, he found himself face to face with a police officer.

The lawman escorted Nerburne to the station, confiscating the butter. Nerburne claimed to have bought the butter from a local farmer. When the police chief inspected the butter, however, he determined it had been packaged in a style consistent with a grocery store or warehouse rather than a farm. Nerburne must've stolen the dairy product.

The search for the source of the burgled butter commenced. Eventually, the police chief showed the butter to the sheriff, who recognized the purloined package as belonging to a shipment of goods destined for the Mariposa mine. The goods, including eight boxes of butter, had sat in a ship on the Canadian side of the Soo, across the St. Mary's River from the American part of the town. The Canadians caked their butter differently than the Americans, and the method seen in the crate of stolen butter matched the Canadian style.

Nerburne might have thought he would get away with the theft if he hopped the river to hawk his goods on the American side. Instead, he churned up trouble for himself.

A BOY WITH A MUSTACHE

A week before the butter incident, a vertically challenged thief undertook a daring robbery. On November 5 Mrs.

Kaupp was walking home from downtown Sault Ste. Marie wearing a belt bag, a kind of little purse attached to her belt. As Mrs. Kaupp passed in front of the mayor's house, the thief leaped out in front of her, yanked the bag off her belt and sprinted off down the street. At the next corner he stumbled, losing his cap before taking off again.

The thief got away with a whopping eighty-five cents. The two witnesses to the crime did little to help. One witness described the thief as a boy, but the other swore the perpetrator was a short, bald man with a mustache.

A Spectacle of Stupidity

While both Jerry Nerburne and the short snatcher chose the wrong items to steal, a Houghton thief chose the wrong location to practice his craft. In October 1887 the criminal in question sashayed into a local saloon, taking a seat at a table occupied by an older gentleman. The older man was reading but had removed his spectacles, which lay on the tabletop. The thief surreptitiously pinched the eyeglasses and stuffed them into his pocket. Several minutes ticked by before the older gentleman noticed the absence of his glasses, at which time he asked if anyone knew what had happened to his spectacles. The other three patrons in the saloon shook their heads. The proprietor, certain no one had left the saloon, requested that all present empty their pockets. One man refused.

The proprietor dumped the man's pockets for him, and out tumbled the missing spectacles.

Maybe the thief badly needed glasses. Extreme nearsightedness might explain why he thought he could get away with the theft with only two other suspects in the room. Otherwise, the thief had no excuse except acute overconfidence—or monumental stupidity.

THE STOLEN PANTS

A headline in the November 20, 1919, edition of the *Ironwood Daily Globe* declared that a guilty man had proclaimed in court, "I stole the pants!" Why did Jake Weinstein say this, yet still profess his innocence?

Weinstein worked for a company that installed light fixtures for businesses in the Wakefield area. When he installed a fixture for the Bulgarian Bakery and Grocery Company, controversy erupted over a certain pair of overalls. When he arrived at the bakery for the job, Weinstein asked to borrow a pair of overalls. The proprietors obliged. Here the confusion begins. The proprietors accused Weinstein of stealing the pants. The trial dragged on for more than three days.

The charge against Weinstein, as read in court, stated that the proprietors of the Bulgarian bakery owned the pants and that Weinstein "unlawfully took and converted the same to his use." Weinstein admitted in court that he was "guilty of the charge of stealing a pair of overalls" but insisted he did not

"believe" he had "retained possession of them." The question of just how a man can be uncertain whether or not he wore a pair of pants was never answered. The bakers also accused Weinstein of attempting to install a light fixture that was too small. Consequently, Weinstein had to remove the undersized fixture, leaving the bakery with no fixture in that spot for five days. The proprietors claimed losses of $200 caused by the lack of light, along with another $2.50 for the loss of the pants.

Although the trial made the papers, the verdict did not. A pair of overalls can only excite the public's imagination for so long before other matters, like corset taxes in Illinois, boot the pants out of the spotlight.

THE CHAIN GANG

Beginning in 1908 a thief or group of thieves ran wild in Sault Ste. Marie, relieving people of their precious… bicycles. For more than two years, the bicycle chain gang snatched an average of one bicycle each month. The thieves ripped off the bikes out in the open in public places such as street curbs, building fronts and hallways. Yet no witnesses stepped forward to identify the culprits. Sailors visiting the port were mentioned by gossipers as possible suspects. With no evidence to go on, and no eyewitnesses, the police never got further than speculating about what person or persons perpetrated the crimes. No arrests were made, and the bicycles were never recovered.

A Fowl Crime

When selecting a target for robbery, the would-be thief should consider whether he can get in and out without being detected. Some residences have alarm systems, while others have guard dogs. Still others have roosters.

At 4:00 a.m. on March 5, 1910, Officer Matt Mitchell heard a ruckus coming from a chicken coop owned by a local farmer. Curious about what had riled the chickens, Mitchell approached the coop. He found Jack Bonno inside, attempting to capture some of the "fowl" creatures. Since Bonno was not the farmer, Mitchell concluded the gentleman had felonious motives for his game of catch-that-chicken. The cop arrested the chicken-napper, who had to eat crow that night.

The Marshal and the Bad Man

Frank Feeney had earned a reputation as a very bad man long before he ever met Marshal Maney. In February 1899 a judge sentenced Feeney to five years in prison for robbing a jewelry store in the Soo. Just four years later, in March 1903, Feeney was released from the Marquette prison on a Thursday morning. Two days later, he burgled the Marquette Hardware Company. Rumors that Feeney was looking to buy dynamite trickled down to Marshal Maney, who hauled in the ex-con for interrogation.

For some reason, Maney decided to forgo the pat down. The marshal sat Feeney down in his office and turned his back on the bad man whilst filling out paperwork. Feeney, true to his epithet, took the opportunity to do something very bad. When Maney turned around, he found himself nose-to-barrel with a revolver. The marshal calmly inquired what Feeney intended to do now. The *Daily News-Record* quoted Feeney's reply: "Shoot you, by God."

Maney edged toward the ex-con, sneaking a hand down to his own gun. Feeney, bad as he was, seemed hesitant to pull the trigger. Another officer in the room at the time kept still, apparently more convinced by Feeney's gun-wielding than the marshal was. Maney whipped out his own weapon, tackled Feeney and disarmed the criminal. Finally, the cops decided the time had come to search Feeney. Concealed within his clothes, they found three revolvers in addition to the one he had waved in the marshal's face, eight razors, several pocketknives, hair clippers, a box of ammo and some watches.

The value of the items exceeded $100. A later investigation determined that all the items came from the Marquette Hardware Company and that Feeney had entered the premises through a transom. Feeney didn't deny the charges. Authorities expected the thief to nab himself a long sentence in the Marquette prison.

Bananas and Beer

For six months in 1901 a band of brazen thieves terrorized Sault Ste. Marie with their capers. Finally, in October, the gang was captured by authorities and forced to answer for their crimes. The thieves—three young boys whom the *Soo News Record* described as "operating in the city with startling success"—had committed numerous crimes to which they confessed after their arrest. The final crime involved breaking into a store. Before that, the boys had robbed freight cars at the rail yard, making off with bananas and ten cases of beer. They also pinched dozens of items from local stores, including five pairs of shoes, fishing tackle, agate jewelry, knives, plug tobacco, stamps, sixteen dollars in cash and ammo. They even stole money from their own fathers.

If they hadn't gotten caught, perhaps the boys would've started their own general store.

Done In, Done Wrong

Everyone dies. Most people die of natural causes or from an accident, but once in awhile somebody dies under suspicious circumstances. In these cases, rather than death being the end, it's merely the beginning.

CURSE OF THE BONES

In the first decade of the twentieth century, Chippewa County became the epicenter of a strange mystery. Wildfires had recently ravaged the area. While out inspecting the damage, a group of local landowners stumbled upon a gruesome discovery under the floor of an empty cabin near the village of Dick. There, lying on the ground, they found the better part of a human skeleton. The remains included portions of the arm and leg bones, the torso bones and a piece of the mandible with some

teeth still attached. The wildfire had burned up the rest of the skeleton. The homesteaders also found in the vicinity of the skeleton the remnants of a gold watch and an emblem rumored to signify either a labor organization or a secret society. The prosecuting attorney and sheriff were informed of the discovery. A deputy headed out to the cabin to collect the bones.

After authorities examined the remains, they determined the individual probably died as a result of foul play, though the exact cause of death proved difficult to pin down with nothing left but the bones. However the victim died, someone stashed the body under the cabin's floorboards on top of the ground, rather than burying the remains. No one could say how long the body had lain there. The prosecuting attorney, George B. Holden, took possession of the bones, keeping them in a small wooden box.

Nothing found with the bones gave any clue to the victim's identity. No one had been reported missing in the region either. Local gossip centered on the man who had most recently lived in the cabin, James Janes, a middle-aged hermit well known in the region. Janes lived in the cabin until 1901, when he moved to another property he owned near Rudyard, not far from his cabin at Dick. In December 1904 Janes received a jury summons and reported for duty. He didn't make the first cut, so he had some time to kill while waiting to find out if he would make the next cut and be seated on a jury. Unfortunately, the hermit suffered from a common affliction—alcoholism.

With nothing to do except wait, Janes paid an extended visit to a local pub. By morning, when the court called on him again, Janes was knee-deep in a hangover. The judge dismissed him, but not before chastising the hermit for his lack of self-control.

Janes slogged back to his cabin all alone, overwhelmed by remorse, with no friends to comfort him. After composing his will in red ink, he picked up his shotgun and fired it straight into his own forehead. The hermit left all his property to the only friend he had. In his will, Janes asked to be buried where his body lay, in a simple wooden box with no minister present. Less than two years later, the skeleton would turn up under the floorboards of the cabin he abandoned several years earlier. Though gossip mongers speculated Janes might have been responsible for the death of the unknown victim, few folks really believed him capable of such a heinous act. Nobody knew where Janes came from or anything about his life prior to when he showed up in Chippewa County.

In January 1909, just over two years after the discovery of the bones, the hermit would make another court appearance. Since his estate went unclaimed after his death, in January 1909 the court declared the personal property of James Janes would revert to the government. At the same time, George B. Holden handed over to the deputy sheriff the little wooden box housing the anonymous bones found under the cabin once owned by Janes. Two lives passed into obscurity that day, leaving

behind a mess of mysteries. Who was James Janes? Whose body was stashed under the cabin and, if the person was murdered, who had committed the crime?

Neither mystery was ever solved.

GETTING AWAY WITH IT

One evening in November 1889 a train came barreling down the tracks from Ironwood. As the train passed the village of Siemens, a few miles outside of Ironwood, the man tending the locomotive's fire noticed something on the tracks ahead. Too late he realized the object was a man lying flat on his back alongside the tracks with his head resting on the rail. The train struck the man before the crew could stop the locomotive. When the train finally screeched to a stop, the fireman jumped out to check on the man. The poor sot was badly injured, with numerous cuts to his head, but he was still alive. Later, authorities would learn the man's name was Mat Johnson—and that the incident on the tracks was no accident.

Doctors determined Johnson's head wound could not have been caused by the accident, but must've resulted from a whack in the head with a blunt instrument. On the evening in question, Johnson got a bit drunk in the saloons of Ironwood along with a couple of pals. The three men departed the town on foot, following the train track. A bit later, the train crew ran into Johnson, literally.

The fireman who found Johnson glimpsed another man fleeing into the woods and took off after the suspicious character. After catching the man, the fireman hauled him into the marshal's office in Bessemer. The suspect admitted to knowing Johnson but denied any involvement in the attempted murder of his companion. The authorities could find no evidence linking the man to the crime. The suspect was set free.

Johnson recovered from his injuries. He had no memory of the night he was attacked and left to die on the tracks. The person who tried to kill him got away with it. As with the skeleton under the floorboards, authorities failed to crack the case of the near demise of Mat Johnson. Let's hope he wore a helmet on future beer binges.

Shall I Shoot Him?

One Sunday night in November 1919 Mike Trovich of Hurley, Wisconsin, got drunk and kicked his wife out of the house for reasons nobody knows. He demanded she beg to be let back into the home—and he wouldn't accept no as an answer. When Mrs. Trovich declined her husband's kind invitation, he grabbed a gun with the avowed intention of shooting her unless she got down on her knees to beg his forgiveness. The missus took off into the woods. Later that evening, Trovich found her hiding out at the home of Nick Cochelivich, across the Michigan state line. Trovich burst

into the house with one hand in his pocket, declaring he had a gun that he would use on his wife unless she returned to their home with him at once. Mrs. Trovich refused. The *Ironwood Daily Globe* reported that at this point Cochelivich decided "he didn't want any killing in his home and he asked the couple to please step outside." The Troviches left via separate doors.

No one knows what happened next. The next morning, Mrs. Trovich showed up at the courthouse, only to be told she must find an interpreter before the court would hear her complaints, as apparently the woman spoke little English. Mrs. Trovich never came back to the courthouse. That night, Mike Trovich visited Bozo's saloon, where he ran into Nick Cochelivich. Trovich hadn't seen his wife since leaving the Cochelivichs' house the night before, so he naturally assumed Cochelivich was harboring her. When he found Cochelivich in the saloon, Trovich demanded the immediate return of his wife. The other man shrugged off the demand, since he had no idea what became of Mrs. Trovich after he evicted the couple from his home.

The drunken Trovich bristled at Cochelivich's answer. Armed with an empty beer bottle, Trovich lunged toward Cochelivich. Suddenly, he stopped. Trovich dropped the bottle and yanked out a brand-new automatic handgun. Thus armed, Trovich inquired of the crowd, "Shall I shoot him?"

The bartender hollered for someone to stop the dimwit. Trovich was tackled and disarmed. Authorities took

him straight to jail and to court the following morning. Thereafter, Mrs. Trovich stayed home with their four children while her husband spent some quality time with the cops. The bozo got his comeuppance at an aptly named saloon.

DEATH HOUSE

In November 1902 Dr. E.H. Webster of Sault Ste. Marie looked forward to moving into his newly built home. Workers had finished constructing the house just a week earlier when a steamfitter called Cumbersworth, hired to install a heating system, made a macabre discovery on the third floor of the home. He found a dead man lying on the floor.

No one knew the dead man. Since no workers other than Cumbersworth had entered the house since its completion, the body may have rested there for a week undiscovered. The coroner determined the man was about twenty-five years old and probably died from poisoning. The dead man had with him a watch, a broken thermometer of the type used by doctors and a small vial. The *Daily-News Record* declared that the authorities had "absolutely no means of identifying the man." With no family to claim the unknown man, he ended his days in a pauper's grave. The answer to the question of whether the man poisoned himself or someone murdered him was buried with him.

THE WICKED WIFE

Laboring in the deep, dark copper mines of the Keweenaw was backbreaking work. The miners worked by the light of tiny candles thousands of feet within the earth, hammering and blasting bits of copper from the rock. Such work could break a man's body, but could it drive men insane?

A man called Harris, who worked in the Cliff Mine north of Calumet, may have hoped for a verdict of temporary insanity brought on by mining conditions. Otherwise, his actions in December 1862 would surely land him in prison. Harris worked the night shift at the mine, leaving his wife alone during the hours when many men were free. The Harrises operated a boardinghouse. Eventually, gossip about Mrs. Harris and Mr. Richards, one of the boarders, trickled down to Mr. Harris. The wife herself even enjoyed taunting her husband with hints about her affair. He ordered Richards to vacate the premises, but the other boarders saw Richards sneaking into the house after his eviction, on the evenings that Harris worked.

News of the late-night trysts between Mrs. Harris and the boarder circulated all over town, until no one could ignore the issue—including Harris's bosses at the mine. The mining captains chastised Richards for his unseemly behavior and commanded him to keep away from the other man's wife. Whatever Richards may have told the captains to escape their wrath, he just couldn't stop himself from misbehaving.

One evening in December, Richards took Mrs. Harris on a romantic sleigh ride. When Mr. Harris learned of the escapade, he rushed out to buy a double-barreled shotgun. Back at home, he stashed the loaded gun under the staircase. Two nights later he put on his work clothes, grabbed his candles and left the house as if going to work as usual. Assuming he had fooled his wife, Harris doubled back and crawled under the house to hide. Sometime later, his wife went into town. Harris waited under the house for two hours until she returned. Then he heard his wife talking to someone inside the house, someone whose voice sounded suspiciously like that of Richards. Harris scrambled out from under the house intent on confronting his wicked wife and her paramour, but the front door was locked. Grabbing an ax that lay on the ground, Harris thrust open a window and climbed inside. Through an open doorway he could see his wife and Richards huddled by the wood stove sharing a drink. The sight proved too much for Harris to take. He barreled into the room wielding the ax.

Two men who also boarded at the house saw Harris and jumped on him, relieving him of the ax. Harris seemed to relax, so the men let him go. The mad miner even reassured Richards that he would not harm him if Richards would sit down with him to have a chat about the situation. Just as everyone let out the breaths they'd been holding, Harris bolted for the staircase. He whipped out the shotgun hidden there, raced back into the room and fired at Richards. The shot struck him smack in the chest,

near the heart. The gunshot wound alone would've done in Richards, but Harris wasn't finished yet. He turned the gun on his wife, who begged for mercy. One of the other boarders tore the gun from Harris's grasp.

Harris nabbed the ax from the floor. Before anyone knew what was happening, he drove the ax into Richards's head. The blow split the front of his skull wide open. With his rage satiated, Harris dropped the ax. When the police arrived, he gave himself up without a fight. Despite the savage nature of the attack, public sentiment seemed to favor the homicidal Harris. As the *Houghton Mining Gazette* said, "There is much sympathy felt for Harris who is said to have been an honest, steady man, and well liked by everybody acquainted with him."

Everybody except Mr. Richards, that is.

Off with Her Head

When confronted with an annoying specimen of humanity, an average person might jokingly say, "Off with your head!" In July 1904 one man took the saying literally. Daniel Bunkley had traveled from the Detroit area to Manistique in the central UP accompanied by another man called Davidson and two women, Mrs. Lillian Proctor and her daughter, Pearl Stanaway. The two couples signed into the Hiawatha Hotel in Manistique as husband-and-wife pairs, though it seems doubtful they were actually married.

Stanaway's husband disappeared some years earlier, leaving her free to carouse. She and her three friends raised such a ruckus on the train up from Detroit that both the conductor and brakeman had to intervene to keep the group under control. Problem was, the foursome all enjoyed whiskey a bit too much.

After checking into the Hiawatha Hotel about 8:00 p.m. on a Thursday evening, the quartet proceeded to drink some more. The next morning, the foursome ate breakfast together without incident. The men headed out to look for a location for a restaurant that Mrs. Proctor and Mr. Davidson wanted to open. When the men returned in the afternoon, they found the women "in a beastly state of intoxication," as the *Soo Evening News* put it. The hotel, it seems, had sold the women an inordinate amount of whiskey during the morning. The men left again. At dinner time, Mrs. Proctor waited alone at a table in the hotel dining room for the men to return from their trip. Mrs. Stanaway waited in the room she shared with Bunkley.

When Bunkley and Davidson came back to the hotel, they saw Mrs. Proctor in the dining room still in a disreputable condition, thanks to the whiskey. She asked Bunkley why his "wife" refused to come down for dinner. The question caused Bunkley to march over to the bar and order a bottle of whiskey. He told the bartender, "This will do the work." Although the request made the bartender suspicious, he could do nothing except caution Bunkley to be careful. Bottle in hand, Bunkley stalked upstairs to his "wife."

Pearl Stanaway was in their room, drunk as usual. The events that followed are a bit murky, as Bunkley's story left many holes in need of filling. Something incited his anger, however. Bunkley grabbed a razor and slashed Stanaway's throat—so ferociously the razor nearly decapitated her and the blade broke off on her spinal column. Bunkley fled the room with the broken razor in his hand. Stanaway died instantly, with no chance to let out the slightest cry for help. No one in the hotel, not even guests in the surrounding rooms, knew what had happened.

From the dining room, Mrs. Proctor saw Bunkley in the upstairs hall. She ran to him, asking why her daughter still did not come down for dinner. Bunkley replied, "She wants no dinner. I have done it now. Come and see." Then he flung open the door to the room, revealing the carnage.

Stanaway lay on her back on the floor, her head all but disconnected from her body. Blood soaked the body and everything around it. Later, Bunkley would tell police Stanaway died without a struggle, but her clothes were torn and the sheets were ripped off the bed. When asked about his motive for the killing, Bunkley stated calmly, "I killed her because I was in love with her and couldn't do anything with her, to stop her drinking and carrying on."

Why, then, did Bunkley take a bottle of whiskey up to his "wife"? No one would ever know the truth behind the brutal events that took place on that July evening in 1904.

Bumped Off in a Brothel

In the late 1800s, Dave LeRoy earned a reputation as one of the nastiest men in the western UP. The mines and lumber camps attracted unsavory characters bent on bending the law whenever and wherever they could. LeRoy was one such character—a gambler, as well as the proprietor of a house of ill repute. He operated two brothels, one in Iron River and another across the border in Wisconsin, along with the saloon/hotel in Stambaugh where he lived the high life with his wife. An accident had left him with one leg shorter than the other. In spite of his injury, the tall and wiry LeRoy cut an imposing figure with his patrician features, steely blue eyes and long black mustache. But it was LeRoy's ruthlessness that most intimidated folks.

Mrs. LeRoy lived in both elegance and ignorance with her husband. At home, he behaved like the perfect husband, while at his cathouses he treated the women with disdain. LeRoy's wife apparently knew nothing about his side businesses, until the day he died.

On that day, LeRoy headed to his brothel in Pentoga, southeast of Iron River. Dick Rogers, a frequent visitor to the establishment, had been raising a ruckus with his drinking and brawling. Frank Long, who ran the Pentoga house for LeRoy, had warned Rogers to shape up or he'd let LeRoy take care of matters. Normally, such a threat would scare sense into a troublemaker, but Rogers must've fancied himself tougher than the fearsome brothel keeper. Rogers

kept up his bad behavior, until LeRoy would brook no more mischief from him.

LeRoy stomped into the room where Rogers was enjoying the company of a woman who was not his wife. Rogers cursed LeRoy, swearing he would pound the brothel keeper into an early grave if the man didn't exit the room forthwith. LeRoy refused to back down. Just as LeRoy strode toward the bed, the woman whipped a pistol out from under her pillow and tossed it to Rogers. The blaggard shot LeRoy three times without even getting out of bed. LeRoy stumbled out the door, aiming to grab a gun. He made it outside, as far as the doghouse, before collapsing—dead.

The following day, LeRoy's body was transported to Stambaugh. The driver of the sleigh that ferried his blanket-shrouded body to the undertaker's made a pit stop at a saloon en route. There, spectators congregated around the sleigh for one last look at one of the most feared men in the region. One onlooker, a meek barber, mustered the gumption to fling the blanket off the body and declare, "That's the best I've ever seen you look, you dirty SOB!"

Although his ladies of the night served as ladies in mourning for the occasion, few of the local folks attended LeRoy's funeral. The cops arrested Rogers, but a judge let him go without bail on Rogers's promise to return later for a hearing. Rogers never stood trial. Locals didn't mind, however. They would gladly have paid Rogers a reward for ridding them of the cruel cathouse operator.

The Bad Guys

Murder is the most extreme form of crime, but lawbreakers can choose from a long and varied menu of other crimes. Yet catching the criminals often failed to stop their exploits. A nefarious-minded individual could find plenty of bad things to do from inside, or outside, prison.

Too Crazy for Jail

In July 1903 three criminals were transported from the prison in Marquette to a mental facility in Ionia. The men—Charles Johnson, Charles Henson and Edward Alore—were all sentenced to life in prison after being convicted of murders. Finally, authorities judged the trio too crazy for jail, hence the transfer. Just three months earlier, Johnson had nearly died in a prison fight. He and

FORGOTTEN TALES OF MICHIGAN'S UPPER PENINSULA

another lifer, Eric Kangas, got into an argument while working in the prison shoe shop. Johnson grabbed a hammer and jumped on Kangas, who fought off Johnson with a knife from his workbench. By the time the guards separated the prisoners, Johnson had suffered a number of injuries. His nose was nearly cut off, while one of five stab wounds on his neck came within an eighth of an inch of severing his jugular. Kangas escaped uninjured.

Kangas had already served ten years of his life sentence, by all accounts peacefully. Johnson, however, had entered the prison just a year earlier. The guards and other inmates knew him as a brooding man, clearly angry at the consequences of his actions. The murderer felt put upon and decided to put up with it no longer. His actions landed him in the infirmary and, three months later, the loony bin.

NOT SO FAST...

The pressure of prison life provoked Charles Johnson into an act of rage against another prisoner. Some convicts respond in a different way, becoming despondent over their fates. In December 1901 Frederick Schultz sat on death row, waiting to be hanged in February. His anxiety got the better of him, and he stabbed himself in the neck with a piece of steel from a lady's corset. Newspaper accounts failed to mention how Schultz got a piece of steel. The wound caused so much damage that

100

Schultz had trouble eating. He endured severe pain, but authorities made sure Schultz got the best care to keep him alive and in good health.

As the *Soo News-Record* explained, everyone wanted Schultz to survive so he could "successfully pass through the trying ordeal of being hanged on February 7th next." Schultz, on the other hand, hoped to spare himself the trauma. In the UP, murderers don't get off that easy.

DON'T MESS WITH THE FEDS

In April 1888 two prisoners awaited their trials at the Ironwood jail. James Keen was charged with breaking into a store. James Joyce had been arrested for selling liquor without a license. Both men enjoyed the hospitality of the county, confined to a corridor in the jail. One evening, the watchman gave the men their supper and, about 8:30 p.m., left the building for an hour. Keen knew the marshal would arrive the next day to haul him off to Bessemer for trial. The prisoners seized the opportunity.

A door barred their way, sealed by a bar on the outside. Somehow the men unscrewed the bolts holding the bar in place and removed the door's casing. How the prisoners accomplished this feat mystified the authorities, but the cops assumed the men had help from the outside. The casing could not have been broken with bare hands. The men would've needed tools, which they didn't get from

inside the corridor. Despite a manhunt for the escapees, authorities found no trace of the duo.

Nobody cared much that Keen had escaped, as his crime was relatively minor. His escape spared the people from having to pay for a trial. Joyce, however, broke the laws of the federal government. The authorities would keep searching for him, whatever the cost.

Caught

When Billy McLain escaped from the jail in St. Ignace, he wasted no time in getting to his destination. In September 1887 McLain broke out of his cell. He headed straight out to find some friends of his, who—willingly or under duress—armed the man with money and a rifle, which he intended to use for killing any officers who tried to capture him. With the Canadian border so close by, authorities may have assumed that McLain would make a beeline for the shores of our northern neighbor. The bad boy had other plans. He rushed to the nearest brothel and got drunk.

After several hours at the house—ranch, actually—of ill repute, McLain hopped on the four o'clock train to Newberry. The *St. Ignace Republican* pronounced that McLain would "probably never again occupy one of the Mackinac County parlors." They were wrong. After making a rest stop in Newberry, McLain at last made his beeline for Canada via the cross-border town of Sault

Ste. Marie. While McLain hung out in the Canadian Soo, Sheriff McKenzie of Chippewa County waited on the American side, convinced McLain would try to return to his homeland. After several days, McLain did just that.

McLain had barely found his footing on American soil when the sheriff caught up with him. McKenzie apprehended McLain in a saloon, where he and his friends had taken up residence. McLain demanded to see a warrant but the sheriff, certain McLain would escape if given the slightest opportunity, refused to release his prisoner in order to take the warrant out of his pocket. McLain slugged the sheriff in the face and kicked at him. McKenzie held on and yelled for help. Soon, two officers dashed to the scene. McLain was handcuffed, and the trio of lawmen escorted him to his new digs at the Chippewa County jail.

McLain quickly got up to his old tricks. He extricated himself from the handcuffs, breaking anything he could find in the cell until he found an iron strap used to hold some pipes together. With the strap, he attacked the masonry walls. Again, the sheriff and his two officers besieged McLain. This time, they cuffed his hands behind his back. McLain gave them no more trouble. Sheriff McKenzie sent a telegram to the sheriff of Mackinac County, who arrived the next day to transport McLain back to St. Ignace. Everyone expected McLain would receive a good long sentence as a reward for his antics.

THE DESPERADOS

In March 1903 two criminal characters broke into a building in Sault Ste. Marie, rooted through some trash on the second floor and dropped a lit match onto a stack of papers. The duo fled the scene, but the cops already knew the identities of the perpetrators. The pair had already been under police surveillance for some time, suspected of a number of other crimes, including stealing formaldehyde from a mortuary. Why hadn't police arrested the terrible twosome? Well, the cops didn't quite know what to do with them. They were, after all, only seven years old.

The fire department learned of the blaze quickly, extinguishing it before the structure suffered much

damage. The seriousness of the crime forced authorities to arrest the two boys responsible for starting the fire—the terrible twosome dubbed "juvenile desperados" by the *Soo Daily News-Record*. The boys' prank was expected to earn them several years in jail.

BURNED

Hiring someone else to do the dirty work can backfire on an arsonist. John McLachlan learned this lesson in November 1902. When the store belonging to McLachlan's brother Jim burned down, the police tracked down and arrested the arsonist quickly with the help of an eyewitness. The suspect, William Warner, told police a shocking tale. According to Warner, John McLachlan hired him to torch Jim MacLachlan's store.

In the summer of 1902 Warner rented a house in Houghton County, a house owned by John McLachlan. One day John McLachlan approached Warner with an offer for an unusual kind of work. Jim MacLachlan owed his brother $375, but lacked the cash to pay him back at that time. John McLachlan didn't want to wait. He offered Warner $100 if he would set fire to Jim's store, which was insured for $4,000. After his brother collected the insurance money, John McLachlan felt certain he could get his $375. Warner balked at the offer until a few days later, when he got drunk. Weakened by his bender, Warner succumbed to

McLachlan's persuasion and agreed to execute the task. Even after he sobered up, Warner stuck to his end of the deal. At about eleven o'clock on the night of September 16 he broke into Jim McLachlan's store, climbed to the second floor, lit a match and touched the flame to a pile of shavings and tarpaper on the floor.

Albert Haas, who lived nearby, spotted the flames inside the store. He rushed to the building and, finding the back door open, went inside. As he crossed the threshold, he ran into Warner. Though Haas demanded to know what the man was doing inside the store, Warner pushed past him to run out of the building. Haas got a good enough look at the arsonist to help police track down the man. An insurance investigator visited Warner to ask about the fire. At first Warner denied any knowledge of the crime but, swayed by the investigator's persistence, he eventually confessed. The authorities arrested him.

Once in custody, Warner related the story of how John McLachlan had recruited him to burn down the store. He said McLachlan had placed the pile of shavings and tarpaper on the floor and instructed Warner to use those materials to start the fire. McLachlan was arrested too. At the trial McLachlan's attorney tried to vilify the eyewitness, Albert Haas, by painting him as an amateur detective with a hidden agenda—as if that, even if it were true, would excuse McLachlan's behavior. A criminal will try anything to get off, especially after getting burned by his own arson scheme.

Duped Yoopers

Not all criminals are violent. Some prey on people's emotions or rely on sleight of hand, or sleight of tongue, to bamboozle their victims. Just as some criminals avoid violence, certain criminally minded characters seek something other than cold, hard cash.

THE IMPOSTER

In November 1906 a couple of hunters trekked out into the woods of Baraga County hoping to bag themselves some bucks. They succeeded in shooting three deer on the trip. While still out in the woods, they encountered a man who introduced himself as Deputy Game Warden S.D. Thompson. The man demanded to inspect their deer, to which request the hunters acquiesced, leery of running afoul of the law. After inspecting the carcasses, the warden

announced he was confiscating the hunters' kills because they had failed to attach tags to the carcasses as required by law. The hunters argued with the warden, but to no avail. They relinquished their kills to the man calling himself a game warden. Later, they saw Thompson dressing the deer for his own use.

When they got back from the trip, the hunters marched straight over to the top game warden, Charles Chapman. The men related their story and told Chapman they felt certain they had violated no laws. According to the hunters, the laws at the time required that deer carcasses be tagged only when they are about to be shipped. Chapman agreed. If Thompson had confiscated the deer without cause, simply because he wanted some venison for dinner, the act would qualify as a misdemeanor. Chapman immediately contacted Thompson.

The deputy game warden denied any knowledge of the incident. He noted that another group of hunters had their deer stolen a few days earlier in the same area. Perhaps, he suggested, the same culprits were to blame for both incidents. Since Thompson was a well-known and respected man, no one wanted to believe he would steal from some hunters. Chapman also respected the deputy game warden. Everyone seemed to agree that an imposter had borrowed Thompson's identity to con the hunters out of their kills.

The phony game warden conned the hunters out of a few bucks—though not the kind he could spend at the store.

MEATY MANUSCRIPTS

A slab of venison can make a nice dinner or, as one con man claimed, good reading material. In November 1902 Deputy Game Warden A.P. BeDell was called from Menominee to Channing, northeast of Crystal Falls, to watch out for deer poaching. While there, he met a railroad agent who had a suspicious package to deal with and no idea what the box held. The box's label read "books," but the agent harbored doubts about its contents. Maybe he unconsciously detected a whiff of something wafting out of the box. BeDell opened

the box on the agent's behalf. Inside he found 196 pounds of deer flesh, packed and ready for sale.

A bill inside the box named the recipient of the venison as one John Rogers of Chicago. The man who shipped the box gave his name as James Jackson. Investigation revealed his name was really Dave Ward of Channing. The game warden arrested Ward, fining him twenty-three dollars plus costs. Ward paid the fine without complaint.

While BeDell dealt with the illegal-venison shipper, another lawbreaker stole the evidence—the "meat" of the case—from the warehouse where the game warden had stowed it. Luckily, Ward—the con man who tried to pass off venison as books—had already paid his fines.

ONE SHOE SHY OF A PAIR

Sometimes flimflammers cheat people out of items that seem like unlikely objects of criminal desire. The owner of a shoe store in Escanaba discovered one day in November 1902 that someone had stolen a mismatched pair of shoes, leaving behind the mate of each. A few days later a man walked into the store. The gentleman offered to buy one of the left-behind shoes because, he said, he had a friend with a missing foot who obviously needed only one shoe. The shoe seller reached a deal with the gentleman, the man paid and they parted company.

Later the store owner found out the man who bought the lonely shoe was also the thief who stole the other one. He got gypped by a man who couldn't tell his right shoe from his left.

NEVER TRUST THE UNCLE

Before the days of driver's licenses and instant verification, merchants had to accept checks on faith. So when two men walked into B.J. Andary's store in the Soo in March 1910, they knew just how to play the game. The men gathered up $4.50 worth of merchandise from the store and took it to the cashier. When the cashier asked for payment, the younger of the two men, who gave his name as Graff, offered up a check made out to him and written in the amount of $87.50 as payment for the purchase. A century ago $87.50 was a lot of money. The cashier must've looked a bit dubious, for Graff launched into an explanation. The check, he said, came from a Mr. Toney of Marquette, to whom the young Mr. Graff had sold some property—hence the check, which Graff claimed he received as part of the transaction. To further alleviate the cashier's doubts, Graff introduced the other man who had entered the store with him as his uncle. The uncle assured the cashier the check was legitimate. The cashier accepted the check, and the men left the store with the goods.

The next day Mr. Andary, the owner of the store, deposited the check in his bank. The bank promptly sent the check to Marquette for verification. The Marquette bank replied that, yes, a Mr. Toney did bank with them, and he was a prominent citizen in Marquette. The check, however, presented a tiny problem—the man well known in Marquette spelled his name Thoney, not Toney as on the check in question. The check was bogus.

When word of the phony check spread, the picture became clearer. Earlier on the day that Graff presented the bogus check to the cashier in Andary's store, the young man tried to pass the same check at the First National Bank in the Soo. The bank declined to cash the check. Several days later, after successfully using the check at Andary's store, Graff tried the same scam at another store with another check but failed.

Maybe he'd left his uncle at home that day.

TIME TO FLY

Graff succeeded by invoking the name of someone living in a town hundreds of miles away. Another cheater made the mistake of appropriating the names of two men living in the same town as the cheater himself. In November 1887 George Lee waltzed into a clothing store in Sault Ste. Marie to buy some new duds. As payment, he offered a time check from a local employer. The time check certified he had

worked X number of hours, earning X amount of money. Lee asked the store owner to take the time check, deduct his purchases from the amount stated on the check and give him cash for the remainder. The time check seemed legitimate enough, signed by both a foreman named Gee and a Mr. Eckerman; the latter had written, above his name, the assurance "correct." With the time check thus certified, the store owner was about to accept the slip of paper as payment.

Then a man walked into the store. The gentleman was Mr. Gee, the foreman whose supposed signature appeared on Lee's time check. Lee approached the foreman with a spiel about Gee owing him money for two days of work not accounted for on his time check. Gee responded that Lee would get paid for the work he had done, as certified by Gee's assistant. The store owner, overhearing the conversation, asked Gee to verify the time check Lee had presented as payment. Gee needed but a glance at the check to pronounce it a forgery.

George Lee bolted from the store. Everyone assumed he fled to Canada.

A CHANGE OF MIND

Sometimes people remember events incorrectly. A man might accuse his brother of stealing his wallet, only to realize he left it in his other pants. But not everyone makes

such mistakes innocently. Consider August Kangas, a man who got away from it all by getting himself locked up in the Iron County clink in May 1920.

One day Kangas must've gotten bored behind bars. He suddenly proclaimed that the police had stolen $10.00 from him. The prisoner claimed that when he was arrested, he carried with him $32.91 in cash, but after his arrest he discovered ten bucks missing. When Kangas went before the court with his charge, however, he crumbled under cross-examination, admitting he only had $12.65 at the time of his arrest. Then Kangas made his most outrageous claim yet. He told the court he never said anyone, much less the police, took his money.

Why Kangas made the fraudulent claim in the first place remains a mystery. Maybe he hoped the judge would fork over ten bucks to cover the loss rather than expose the police to the embarrassing charge. Instead, Kangas's behavior earned him a twenty-five-dollar fine, plus court costs. If Kangas could do math, he must've groaned when he realized that, after claiming cops stole ten dollars from him, he'd cost himself more than twice as much.

PORTRAIT OF A LIAR

In April 1901 a brazen swindler knocked on a lady's door in Sault Ste. Marie. The man claimed to be selling photo enlargements, so the lady invited him into her home. A

con man said he could take her photos and have them enlarged by W.J. Bell, a photographer well-known in the area. The lady knew of Bell. She agreed to the price the swindler quoted, but suggested she would take the money to Bell's studio to pay him directly. The con man agreed, at first. Toward the end of the conversation, the man changed his mind, attempting to convince the lady to hand over the money to him right then. The lady, growing suspicious, declined the gentleman's offer. Later, she called on Mr. Bell to relate the incident to him. Bell informed the police and offered a reward for the capture of the con man.

The swindler's scheme to fleece money out of the lady by offering to enlarge her photos blew up in his face. Rather than depositing ill-gotten gains in his bank account, the con man would be posing for a photo of his own—a mug shot.

SIN CITY

While in some towns con men hid in the shadows to avoid the eyes of the law, certain other locales became hotbeds of sin where the sleaziest of cheats could make a home. Newspapers chastised these towns for their depravity. By the turn of the century Escanaba, for example, had earned the kind of reputation few towns aim to achieve.

In February 1903 the *Sault Ste. Marie Daily News-Record* described Escanaba as "the home of gamblers, hold up and confidence men, whose depredations have been allowed to go unchecked." Citizens began writing letters to Judge J.W. Stone of Marquette, begging him to help in some way with the "orgy of vice" destroying their town. Stone replied that nothing much could be done since Escanaba's leaders and businessmen partook in the carnival of criminality themselves. Even the police, Stone said, aided the criminal element or, at best, averted their gazes every time someone slipped into illicit behavior. The editors of the Escanaba newspaper surmised from the judge's letter that he expected the citizens of Escanaba to pull themselves up out of the muck. To do so, they would have to con the con men into leaving town.

But Escanaba wasn't the only den of iniquity in the UP. By February 1891 Trout Lake hosted a bevy of bunco men and thieves, earning itself a reputation as a "resort" for such characters. Nearly every day honest citizens of the town fell victim to a scheme of one sort or another designed to relieve them of cash. The situation got so bad that in April a detective traveled to the town under the pretense of needing a vacation for health reasons. A month later the detective, with the help of four police officers, arrested the entire gang of miscreants. The evildoers received free transportation to a resort of a different kind—the Chippewa County jail.

Tales of the Inland Sea

Lake Superior is vast and deep, the largest freshwater lake in the world by surface area, bigger than all the other Great Lakes combined. At its deepest, Superior plunges thirteen hundred feet. Mariners know November as the most dangerous time on the lake—when vicious gales whip up the inland sea, sinking ships—but Superior can take its sacrifices any time of the year. Those who survive the lake's fury often have strange tales to tell.

LOST AND FOUND

On October 4, 1904, the steamer *Zillah* came upon a schooner called the *Ogarita*, which had begun to take on water. The crew of the *Zillah* tried to tow the *Ogarita* into the St. Mary's River, but the tow line broke. The *Zillah* had to leave the *Ogarita* on the lake. Although other boats spotted

the *Ogarita*, none stopped to help the waterlogged schooner. All those who passed by the *Ogarita* said they could see no one on board the vessel.

After awhile, the *Zillah* returned for another attempt at towing the schooner into the Soo. This time the steamer's crew succeeded, hauling the *Ogarita* to a spot on the river near the city, where the schooner spent the night. When rescued, all hands were on board and unharmed. The schooner's cabin, however, had been demolished. The *Ogarita* carried a good bit of lumber on board, and the entire cargo survived the ordeal.

How could passing ships not see the crew? How did the lumber arrive unscathed when the schooner's cabin was destroyed? The mysteries and miracles surrounding the *Ogarita* linger more than a century later.

The Unluckiest Ship

In the latter part of the nineteenth century, a steamer christened the *Mary Wood* ferried iron ore between Duluth and Cleveland with Captain Harding at the helm. In 1907 Harding shared the life story of his ship with the *Soo Evening News*. The ship was launched on a Friday the thirteenth, but the inauspicious timing didn't faze Harding, who dismissed the notion of bad luck connected with Friday the thirteenth as mere superstition. His fellow sailors disagreed. No one wanted to join the crew. Harding needed thirteen days to

scrounge together a crew willing to risk working on the hoodoo-hindered vessel.

After the ill-omened start, the *Mary Wood* and its crew completed their first voyage from Duluth to Cleveland with no trouble. Harding joked to his employers that he had cast off the hoodoo somewhere near Grand Marais by tossing it overboard. Soon the crew would suspect that, after its expulsion, the hoodoo must've clung on to the ship's keel. On the steamer's thirteenth trip, in late November, a fierce gale erupted on the lake.

Just before the gale hit, one of the crewmen realized they had reached the fateful voyage thirteen on the ship launched on Friday the thirteenth. Captain Harding dismissed the man's fears, but the crewmen ran below deck to spread the news that their captain was taunting the fates by dragging them out on a voyage that was surely cursed. The men begged Harding to turn around and head back to Duluth. The captain scoffed at them. That afternoon, the *Mary Wood* steamed headfirst into a powerful gale that raged for hours. Somehow, the crew kept the ship afloat and on course—until nightfall, when the wind shifted, hammering the steamer from behind. Finally, Harding admitted defeat and tried to steer the ship toward shelter at Grand Marais. He could see no stars in the sky. Just when safety seemed within reach, a massive wave slammed into the steamer. The ship spun around nearly 180 degrees. Although Harding struggled to correct the steamer's course, he lost control.

Meanwhile, at the rear of the ship, the men were lowering a life raft. The first mate ran to the pilothouse to fetch Harding, and both men sprinted to the aft section. As they neared the stern, they saw the men trying to climb into the raft, which hung over the side of the ship. Through the howling wind, they heard the men scream. They watched as the life raft and the men clinging to it tumbled overboard, plummeting toward the waters. All the men—save for Harding, the pilot and the first mate—had gone overboard.

Harding and his two remaining crewmen climbed into another life raft. Seconds after their raft hit the water, the *Mary Wood* capsized. Harding and his men battled against the swells, praying their life raft could reach the shore. In the distance they could hear breakers, which told them they didn't have far to travel. The three men clung to the life raft with all their strength, battered by wind and waves. The first mate shouted, "There's no use, cap. I'm all in. I've got to let go. Tell my mother at Ashtabula that I—"

He was washed overboard before finishing his cry. Harding hung on, even after he heard the pilot holler, "My God, I'm goin' down." For two hours, Harding huddled in the life raft, until a wave washed ashore. Harding staggered out of the raft, fell to his knees and prayed. Then he passed out.

In the morning, rescuers found him on the beach near Grand Marais. No one else had survived the shipwreck. The rescuers took Harding to a telegraph station, where he sent a message to his family letting them know he had survived. His wife responded with a telegraphed promise

to get down on her knees at exactly noon on that day and thank God for his safe return. That day was Thanksgiving.

The ship launched on Friday the thirteenth sank on its thirteenth voyage, near Grand Marais—the spot where Captain Harding jokingly told his employers he had cast off the hoodoo everyone thought inhabited his ship.

THE LITTLE SHIP THAT COULDN'T

If the *Mary Wood* suffered from a curse, then the *Independence* must've suffered from low self-esteem. The *Independence* may have been the first steamer to motor across Lake Superior, launching in 1845. The *Independence* featured a full sailing rig coupled with a steam engine, one of the most powerful steam engines of the time, and could zip along at speeds of five miles per hour—quite fast for its day. The Soo locks and shipping canal didn't exist yet, which meant men had to drag the *Independence* overland to Lake Superior. Later, sailors would remember the *Independence* for its unreliability, as it always seemed to find trouble wherever it went.

On its very first voyage the *Independence*, after a stop at Copper Harbor on the tip of the Keweenaw, journeyed down the west side of the peninsula to dock at Eagle Harbor. While the crew unloaded its cargo, a nasty storm rose up on the horizon.

The captain decided to leave right away in hopes of making it to La Pointe, Wisconsin, before the storm hit.

The ship and its crew didn't make it far across the lake before the storm forced them to turn around, seeking shelter along the coast of the Keweenaw. The crew of the *Independence* struggled to keep to the coast without crashing into it as they steered the vessel around the northern edge of the Keweenaw. At last, they found a safe harbor at Keweenaw Point, southeast of Copper Harbor. After the storm passed, the *Independence* steamed back to Eagle River and on to La Pointe.

For the next four years, the *Independence* fought with storms, winning each battle by sheer luck, and even endured a big explosion on board. Along the way, the *Independence* acquired new engines that upped its top speed to eight miles per hour. In 1849, just when it seemed the steamer had outlasted the worst Lake Superior could sling at it, the steamer grounded at Eagle Harbor, where it stayed for two years. When someone finally freed the ship, it set out for the Soo under the direction of a new crew but, a mile away from its destination, the *Independence*'s boiler blew. The ship exploded into bits.

One of the crew members who survived felt sure the explosion cast him at least 150 feet into the air. Spotting a bale of hay flying past him, he grabbed onto it and rode the bale down to the water, where he clung to it like a life raft. The crewman was uninjured. Years later, workers at the Soo stumbled upon pieces of the *Independence*, including its propeller. The propeller was put on display in a park alongside the canal. Despite every effort to keep it afloat, the *Independence* barely lasted through five years on the lake.

Lost on the Lake

Another steamer, the *Julia Palmer*, took to the lake shortly after the launch of the *Independence*. Like the ill-fated *Independence*, the *Julia Palmer* met with plenty of bad luck on the inland sea. Unlike the *Independence*, however, the *Julia Palmer* earned a reputation as a sturdy vessel capable of bearing up against the worst gales Superior could throw its way. On the flip side, the steamer failed to make headway against the gales. The crew struggled mightily, and often futilely, to keep the ship on course during storms. On its final voyage, during the fall of 1847, the *Julia Palmer* was destined for Keweenaw Point, carrying a full load of supplies for the settlers living there. Plans changed mid-journey as the lake whipped up one of its legendary gales.

The crew tried to make for Whitefish Point northwest of the Soo but failed. The gale hurled the steamer past Presque Isle, now located on the northern outskirts of Marquette, where they might have found shelter. By a miracle, the ship avoided the coast and the rocks at Presque Isle that would have torn it asunder. The crew began dumping their cargo, but even this did not help the runaway steamer. No one knew where the *Julia Palmer* was headed. The first mate thought they must be near Keweenaw Bay, while the captain guessed Copper Harbor. Swells tossed the bow to and fro, upsetting everything not tied or nailed down and flooding the decks with each surge. Some hours later, they spotted land—Isle Royale, at the northwestern end of Lake Superior.

The crew tried to get into Rock Harbor, on the northern end of the island, but without success. When the storm lessened at last, the *Julia Palmer* found refuge on Slate Island just off the Canadian shores of Lake Superior. Sixteen days after leaving the Soo, the ship finally reached Copper Harbor. The *Julia Palmer* had avoided the terrible fate that befell the *Independence*, but the second steamer to enter Lake Superior lasted no longer than the first.

COLD COMFORT

Three ships found bad luck on the lake. One group of men discovered they needed no ship to stay afloat in the raging waters of a gale. The group was bound for Eagle River, from Ontonagon on the Keweenaw's west side, in midwinter one year in the late nineteenth century. Feeling the woods might prove too difficult to navigate, the party opted to traverse the ice on Lake Superior instead. As the men passed some sheer sandstone cliffs that lined the lake, the ice beneath their feet split open. Within a few seconds, they found themselves stranded on a raft of ice, separated from the main body of ice by a wide expanse of water, with the cliffs at their backsides and the open lake ahead of them.

The cliffs ran straight up to the water, with no beach between the sandstone and the lake. The current was driving the ice raft out into the open water, where they would surely

perish. With their options shrinking by the second, the men realized they must take action. The cliffs were too steep to climb barehanded. Serendipity lent them a hand, as they just happened to have brought along hatchets. After great effort and many minutes, the group managed to hack makeshift steps into the cliff face and thereby ascended the cliffs to safety.

Even in the face of near-certain death, Yoopers can rely on their backwoods ingenuity to save the day.

Lore of the Folks

Every culture has its folklore, myths and beliefs passed down through the generations, some based on a distant memory of past events and some purely invented. In the early days, the UP became its own little melting pot of cultures—Irish, Cornish, Italian and countless others. Most of the immigrants, who came here seeking work in the mines or the lumber camps, brought with them folklore.

THE ROUP-GAROU

French-Canadian immigrants settled in places all across the UP, particularly in Lake Linden and St. Ignace. They brought with them old French legends about creatures called *loup-garou*. These beasts were people who could turn into animals. In St. Ignace, the French-Canadian settlers called the creatures *roup-garou* and feared the beasts so much

that if they saw a strange man peek into their houses and then seem to disappear, they would shut the windows and doors. They might even seal the cracks around the windows and doors by stuffing whatever they could find into the gaps.

One story about the *roup-garou* revolves around a St. Ignace family called the Champains. The grandmother, Old Sarah, took ill. She stayed sick for quite some time, having trouble breathing, with her condition worsening each night before she went to bed. One night a great owl perched on the clothesline that hooked onto the house just below Sarah's window on the second floor. The owl returned every night at the same time. Sarah's daughter called for a doctor and a priest, but no one could tell what caused Sarah's illness or prescribe any treatment or prayer that might help.

Still, the owl returned each night, seeming to accompany the onset of Sarah's worst bouts. Finally one night, Sarah's daughter asked her nephew to go outside and kill the owl. She feared the big bird would eat her chickens. The nephew took a shotgun and fired at the owl, which dropped onto the ground. The nephew went to put his gun away and then returned to pick up the carcass. The owl was gone. He searched all around the house and down the road. There he found a neighbor woman, Mrs. Lozon, crawling back to her house—apparently injured or sick.

Another neighbor showed up and took Mrs. Lozon back to her sister's house. The woman eventually died from her illness, though no one knew exactly what afflicted her. Immediately after finding Mrs. Lozon, Sarah's grandnephew

sprinted back to the Champain house, shouting that the owl had been no owl after all but a *roup-garou*. As soon as Mrs. Lozon passed away, Old Sarah's condition improved. The family suspected Mrs. Lozon, in her *roup-garou* form as an owl, had hung around outside Sarah's window to put a curse on her. The woman's death ended the curse.

The Lutins

The Celtic peoples of Europe tell tales about small, humanlike creatures with preternatural abilities. Known collectively as fairies, these beings can do good or evil, play pranks or kidnap humans. The French-Canadians who immigrated to the UP maintained this tradition of fairy lore long after their families left their Celtic homeland. They believed in little creatures they called *lutins*. Unlike the *roup-garou*, the *lutins* bemused rather than frightened folks.

The *lutins* were said to have an affinity for horses. They would sneak into barns at night to braid the horses' manes and ride them, returning them to their barns in an exhausted state. Brass rings hung in the mane were said to deter the *lutins* from their antics. At other times, the *lutins* chose one horse that they would spoil by feeding it extra oats and hay, the feed stolen from bags intended for other horses. When a farmer would find the empty feed bags, with one horse clearly having eaten more than the others, he would blame the *lutins*. "That lutin was in last night," he might say.

Few claimed to have seen the *lutins* firsthand. Still, folks could offer up a description of the little creatures haunting their barns. The *lutins* were tiny, no bigger than a monkey, with long whiskers. One tale related by storytellers recounts the near-capture of a *lutin*.

One morning a farmer tromped out to his barn to find one of his horses exhausted. Since the horse in question was normally high-spirited and energetic, the farmer wondered what had changed. Inspecting the horse, he discovered small loops tied in its mane. This, he knew, signified the presence of a *lutin*. Wherever the *lutin* grabbed at the horses' mane, a loop would form. According to certain legends, a horseman who behaved badly during life would in death be condemned to roam the earth as a *lutin*. The farmer decided he must capture the little creature.

For several nights, the farmer and his friends staked out the barn, hoping to catch the *lutin* in action. One night their labors paid off when they spotted a light flickering inside the barn. The crafty little *lutin* had a candle, they deduced. How should they catch the little bugger? Someone came up with the idea of trapping it.

The farmer and his friends dug a miniature tunnel into the side of a manure pile, at ground level, and placed a sack at the end of the tunnel. One man opened the barn door, shaking it to make noise. The *lutin* ran through the open door, straight into the tunnel that ran through the manure pile. The sack was pulled shut around him. Though the little creature struggled inside the sack, the men feared opening the sack in the dark, so they took it into the farmer's house. As soon as the sun rose, however, the farmer and his friends peeked inside the sack. The *lutin* sprang out of the sack, dashed out the window and escaped. The only sign of its presence was a black powder left on the snow outside the window.

In December 1896 John Pomroy wrote to the *Copper Country Evening News* to report on mysterious goings-on in his barn. Every evening, Pomroy said, he combed out his horse's mane. In the morning, however, he would find the horse's mane braided in a manner similar to how humans braid their own hair. Then, in December of 1896, he walked out to the barn to find the door locked from the inside. He had to break down the door to get inside the barn. Mr. Pomroy suspected ghosts were responsible, while

other locals fingered an unknown prankster. Pomroy lived near Lake Linden, a village full of French-Canadians, but apparently never heard the legends of the *lutins*.

Ghosts, fairies, pranksters…the mystery of the identity of the mane braiders has never been solved, though a posse had almost garnered proof positive of the existence of *lutins*. A good legend needs no proof anyway. Half the fun of folklore is wondering if it just might be true.

SWAMP GHOSTS

Some legends can trace their origins back to Old Europe. Others have a more recent origin. Take the tale spun by Francis H. Clergue, a bigwig at the Lake Superior Power Company and the Algoma Central Railway, in February 1901.

The *Sault Ste. Marie Daily News* interviewed Clergue about the possibility of a rail line connecting Sault Ste. Marie and St. Ignace. Clergue explained that his company didn't want to step on the toes of other railroad entities that already had interests in the region. While dispelling the rumors about his company, Clergue mentioned the site of Soo Junction, west of Sault Ste. Marie. The Soo Junction, he claimed, played host to "fearful legends" concerning Chase Osborn, the onetime game warden of the area, and his treatment of errant deer hunters. The legend said that whenever Osborn caught a hunter violating the game laws, he killed the perpetrator and tossed his body

into the frog swamps at Soo Junction. Thus disposed of, the hunters transformed into spirits that haunted the swamps and woods in search of deer they could never find—a fate worse than the fires of hell.

"What a fate!" Clergue told the *Daily News*. "What a relentless game warden!"

Train passengers traveling between St. Ignace and Sault Ste. Marie, forced to take a roundabout route through Soo Junction, often gazed out at those frog swamps while awaiting the next leg of their journey. Clergue claimed those passengers sometimes observed the ghosts of the doomed hunters. He ended his discussion of the supposed legend by stating, "On my journeys from Sault Ste. Marie to St. Ignace I always walk as if I'm in a hurry."

Was Clergue merely lightening the mood during a serious conversation, or did Soo Junction really host legends of spectral hunters? The *Daily News* reporter made no distinction, and neither did Clergue.

And the Rest...

Many stories refused to fit into any category. The tales are so bizarre or humorous, or just plain quirky, that no label will stick to them. Here in the UP, such events and tall tales abound.

PRONUNCIATION BLUES

Immigrants brought with them more than fairy lore and pasties. They also carried with them languages that influenced the geography of the UP, inspiring place names like St. Ignace and Toivola. Modern folks often have trouble pronouncing these place names. But, as it turns out, Yoopers of 150 years ago struggled to wrap their tongues around some of the names too. Take Sault Ste. Marie, for example.

In 1850 the *Lake Superior Journal* talked about the problem facing the Soo. Hardly anyone outside the town could

pronounce the name correctly. Is it "Salt Saint Mary"? Nope. How about "Sow Saint Marie"? Wrong again. The *Journal* article listed various ways people have addressed their letters to the paper, misspelling the town's name in unusual ways—from "Susan Mary" to "Sue Sal Mary" and even "Susannah."

The town's nickname, the Soo, provides a clue. It's "Soo Sainte Marie." Any folks who still can't wrap their tongues around the full name can stick with "the Soo." Just don't address mail to "Sue, Michigan."

BESSEMER VS. IRONWOOD

After an influx of new residents in the mid-1880s, the village of Bessemer became incorporated in 1887. Today the town sits in Gogebic County, which snuggles up to the northern portion of the Wisconsin border. Back in the 1880s Bessemer, along with the nearby village of Ironwood, resided in Ontonagon County. On June 4, 1886, residents of Ontonagon County voted on a measure to split the county in two. All but one resident approved the measure, and in February 1887 the state legislature passed a bill that created Gogebic County, excising it from the neighboring Ontonagon County. Now the fight began.

Where should the county seat lie? Both Bessemer and Ironwood vied for the title, with residents of both burgs taking outrageous measures to ensure their town's victory.

An election was held to decide the issue. The human residents of both towns cast votes in their own names, as well as on behalf of everyone and everything they could think of, except their pets, livestock and household goods. One man drove his wagon team back and forth between a nearby mine for the entire day of the election, transporting miners to the polls. He made numerous trips, not to accommodate a large number of miners, but to allow each miner to vote as many times as he wanted.

Bessemer won the election. Whether by rights or by tricks, no one can say for certain. When two frontier towns battle for supremacy, the rules fly out the window faster than a feather in a tornado.

The Ten Plagues of Hancock

Long before Bessemer and Ironwood duked it out over county seat privileges, one Keweenaw town had earned a reputation as the baddest mining town in the district. Residents of surrounding towns and villages gossiped about the wild streets of Hancock, home to the Quincy Mine and its rowdy workers. No one wanted to catch "Hancock fever," an affliction purported to have reached epidemic proportions in the village. But according to one anonymous resident of Hancock, who wrote a letter to the editor of the *Houghton Mining Gazette* in September 1862, the town was being maligned without cause.

The writer expressed dismay that visitors to the region who stopped on the opposite bank of Portage Lake, at Houghton, would "naturally suppose from what they hear [about Hancock] there that the ten plagues of Egypt were raging in our midst, and that it would be instant death for them to visit our side of the ditch."

Hancock's reputation was undeserved, the writer explained. Folks from surrounding towns wanted to believe

the worst of Hancock. So when those folks spotted a couple of men bickering on the street, the gossip turned a simple disagreement into an "Irish row," in which dozens of men got hauled off to jail. Not so, said the writer. Hancock was not cursed with filthy streets, the town's water was not poisonous and the air was not tainted with the stench of rotting flesh. Why, the writer wondered, did Houghton folks think Hancock's Episcopal church was a pigsty until the establishment moved across the lake into Houghton, where the church became a wondrous house of God?

After outlining the countless sins attributed to Hancock, the writer then proclaimed that the people of Hancock were "not entirely ready to believe that nature has lavished all her charms on the beautiful village of Houghton." The writer admitted that both Hancock and Houghton had tallied an unusually high body count in 1862, but claimed that in Hancock the untimely deaths stemmed from "too free use of decomposed and stale vegetables." In Houghton, however, the mortality rate was the result of "bad morals and bad whiskey."

Well, at least everyone knew how to pronounce Hancock.

THE DRY HOUSE GHOST

One midnight in early November 1896 George Kopp went into the dry house, the building where miners change into their work clothes, at the Quincy Mine near Hancock. Kopp

was in the process of exchanging street garb for work attire when an apparition descended before him. It appeared to be a man, stocky and tall. But the apparition hovered above the lockers where the miners stored their clothes, an unusual place for a man to hang out in the dry house. Just as Mr. Kopp wondered how the big guy could float there, the apparition swooped down toward the floor. The ghostly miner vanished into a work boot next to the wood stove. Kopp and his dog hightailed it out of the dry house.

The very next day, Kopp quit his job. Nothing and no one could convince him to return to the dry house. Some people may have wondered whether Kopp wet his whistle a bit too much before entering the dry house that night. Others probably accepted the story without question. Like the men at the Aragon Mine...

HAUNTED MINE

In November 1901 men working the night shift at the Aragon Mine in Norway—the town in the UP, not the country—glimpsed a strange sight. While riding a car up from the bowels of the mine, the men witnessed an apparition of a man in miner's clothes perched on the lip of an empty ore car in the next shaft over, which was used only for transporting the ore out of the mine. The ore car was in the midst of being lowered to the bottom to pick up more cargo. The men said the ghost grasped an iron bar

in each hand, twirling the bars at the men as the two cars passed by each other.

The miners reached the surface in a tizzy, their faces pale. They recounted their experience to the other miners, who shared the story with their friends and family, who in turn told their friends, who told their friends and so on. Soon, the sinister saga had spread all over town. The *Ironwood News-Record* blamed the incident on the "proverbial superstition" of the men who worked the mines, "particularly that displayed by miners of Cornish descent." Among the miners who didn't witness the apparition, many doubted the story. Enough believed it, however, to hinder the mine's operation. Believers in ghosts took the sighting as an ill omen and balked at descending the shaft at night.

As soon as the men in charge found out about the goings-on at the mine, they knew they must come up with an explanation to soothe the miners' fears. A group of mine officials climbed into a car and rode down to the level where the miners had seen the apparition. They inspected the area but saw no ghost. They did find a couple of timbers rotting from moisture. Wet wood can give off a phosphorous glow, so the officials decided this was the solution to the mystery of the phantom miner. The ghost was nothing more than an optical illusion, caused by the phosphorous glow given off by wet wood combined with the fertile imaginations of those silly Cornish miners.

The rotting timbers were replaced. The officials managed to convince all but a handful of the miners to return to the night shift. While the men still talked about the apparition after going back to work, no one else reported seeing it.

SCARED WITLESS

While the men at the Aragon Mine may have gotten worked up over some rotten timbers, a worker at the Pewabic Mine near Hancock had plenty of reason to come unhinged. The incident happened in October 1862. The worker had gone to examine a section of the mine by himself when there was an explosion. The blast terrified the man so much that he took off through the mine like a wild animal on a rampage. Through the tunnels he ran, past his coworkers, without stopping until he got to the surface. There he stopped and seemed to recover his wits. Other than a few cuts and bruises, he was uninjured. His flight from the mine saved his life. He would have been buried in rock had he stayed put.

Sometimes losing his mind temporarily has its benefits for a man.

THE FLYING ROCK

When Mr. Merrick started down Quincy Street one afternoon in April 1897, the Hancock resident probably

wasn't thinking about rocks. But soon he would understand the adage about sticks and stones versus words better than he might have ever wanted.

Merrick had just passed Kerredge's store on Quincy Street, in Hancock, when an object slammed into his head. Glancing all around, Merrick saw neither the object nor the person he assumed threw the object. He reported the incident to the authorities, though with no evidence to hold in their hands they could do little to track down the perpetrator. The object was presumed to be a rock hurled from a slingshot or perhaps a round from an air gun. According to the *Copper Country Evening News*, such weapons had become "much too common in the hands of youths of Hancock."

The reason for the attack would remain as much a mystery as the perpetrator's identity. While sticks and stones can break bones, Mr. Merrick apparently survived the attack without serious injury. He may have thought of a few choice words to sling at his assailant, however.

Delusions of Grandeur

In the nineteenth and early twentieth centuries, J. Pierpont Morgan was perhaps the most famous financier in the world. Even the United States government borrowed money from him. So when a gentleman marched into the office of Justice Jackola in Calumet and gave his name as

J. Pierpont Morgan, the judge had his doubts. First of all, Jackola probably thought it unlikely the magnate would walk into a judge's office wielding a big knife. Mr. "Morgan" informed Jackola that he'd just come back to America after a yacht tour around the world, docking his boat at Hancock. From the marina, he ambled the sixteen miles up Quincy Hill to Jackola's office in Calumet. The would-be magnate claimed to have just settled a coal strike elsewhere in the country. Now he intended to show the people of the Copper Country how to run their mines properly.

The man must've amused Jackola, for the judge let him ramble on for the better part of an hour. The encounter ended when a police officer showed up looking for the strange man. As it turned out, the man was a sailor whose mental ship had capsized some time ago. The loon—real name Murphy—got kicked off the ship he was serving on due to his mental instability. His coworkers decided Hancock looked like a good place to dump a deranged seaman. The officer hauled him off to jail, where he could use his financial skills to drum up the money for bail.

A CRIMINAL CLINCH

In April 1903 the residents of Sault Ste. Marie endured a series of bizarre assaults that left women too terrified to walk the streets alone. The criminal, clearly warped beyond reason, would attack in broad daylight or at night

and always out in the open. How could Sooites defend themselves when the madwoman seized them and…

Gave them a big hug.

Yes, that's right. A mysterious woman would dash up to her victims and throw her arms around them before they knew what was happening. She would let them go just as quickly, fleeing down the street out of sight. The woman targeted mainly other women, a fact that seemed to disturb people more than any other aspect of the "crimes." In one case, the mad hugger ran up to a woman who was out for an evening stroll with her husband. Before the husband

could react, the woman caught his wife in a clinch, released her and took off into the night.

The *Sault Evening News* called the perpetrator a "strange freak of a young woman." Witnesses described the suspect as good-looking and well dressed. Her hug-and-run pranks had the whole town talking and all the women unnerved, yet she went uncaught.

Who's that Man?

In 1912 an unfortunate man entered the county hospital in Menominee. He was unfortunate three times over—he was paralyzed, he had lost one leg and he suffered from amnesia. For two years, authorities endeavored to solve the mystery of his identity, as well as what had happened to him. Hundreds of people around the country wrote to ask for more information about the man, each hoping he might be a missing relative. None of the leads panned out, and none of the folks inquiring mentioned a missing limb. The last to inquire about the man was a Mr. Elrick from Pittsburgh. Shortly thereafter, the man died in the hospital. Authorities never did determine his identity.

The man the papers dubbed the "Man of Mystery" stayed an enigma even after death.

Alarming Letters

In June 1903 an elderly gentleman wandered the streets of Sault Ste. Marie in search of a mailbox where he could post his letter. He happened upon a box that looked similar to the kind he sought. This box, however, had no slot through which to drop letters. Undeterred, the gentleman pulled on the box's door but could not get the darn thing open. Then he spotted a key dangling from the side of the box.

Meanwhile, a policeman had taken notice of the man's behavior. He strode up to the senior citizen and inquired as to the man's intentions for the box. The gentleman responded that he just wanted to mail his letter, but the goldarn mailbox wouldn't open. The officer informed him that it was no mailbox. It was a fire alarm box and, if he kept messing with it, he would draw the attention of the entire fire department. The firemen would be none too happy when they discovered the emergency was a false alarm. The elderly gentleman apologized for the mix-up, and the policeman directed him to a real mailbox.

The gentleman was not the first to mistake a fire alarm box for a mailbox. A year earlier, another man had attempted to deposit his mail in the fire alarm box, breaking it open in the process. The firemen arrived to find the emergency consisted of a confused man with a letter in his hand.

The *Evening News* suggested, "The ways of the city seem to puzzle the denizens of the back districts." Maybe they should've tried emblazoning their fire alarm boxes with the words "fire alarm" in big capital letters.

A Day at the Beech

In the early days of the UP, nearly every day brought new discoveries about the flora and fauna of the region. The unknown far outweighed the known. In spite of this, many people felt qualified to pronounce what could and could not exist in the northernmost reaches of Michigan. Common wisdom of the day dictated that no beech trees could grow in the Upper Peninsula due to the soil conditions and harsh climate. In 1902 rumors circulated of a philanthropist who would pay a reward of $500 to any individual who could provide proof of beech trees growing in the woods of the UP. In November of that year, a man called O'Conners marched out of the woods with an announcement. He had found not one, but four trees of the beech variety thriving in the woods near Iron River.

Unfortunately, Mr. O'Conners didn't know the identity of the philanthropist. No one else seemed to know either. O'Conners may have taken some solace in the knowledge he disproved a long-held myth about the woods of Upper Michigan.

Or maybe he just felt cheated.

Walk, Don't Trot

An awful lot of people take speed limits as suggestions rather than requirements. Today, speeders can contest their tickets in court. A century ago speeders could do the same thing, with one difference. The transportation ran on oats instead of gasoline.

In June 1910 Tom Leonard appeared before the court, accused of speeding on the Fort Street bridge in Sault Ste. Marie. Leonard faced a fine of fifteen dollars or fifteen days in jail. Leonard swore he never drove his horse over the speed limit, which required horses to remain at a walking pace. Officer Haller alleged that Leonard, clearly intoxicated, dared to trot his horse over the bridge. While Leonard admitted to downing a few beers, he denied both being drunk and exceeding the speed limit. The judge sided with Officer Haller. Leonard spent the next day trying to raise the funds to pay his fifteen-dollar fine.

The lesson is clear. If a friend tries to drink and drive, take away his reins.

Another Man's Treasure

An old house can turn into a money trap, swallowing the owner's hard-earned cash as he works to fix up the place. For John Griffiths, however, an old house turned into a treasure. Griffiths had bought an old house in Munising,

then set to work tearing it down to make room for a new building. The house had been built many years earlier by a strange man who later hanged himself inside the abode. The house inspired a different reaction from Griffiths when he found, hidden within its walls, a hoard of gold and cash amounting to several thousand dollars. Everyone assumed the eccentric who hanged himself in the house had stashed the treasure there. But why would a man in possession of such a treasure end his own life?

That's a mystery no one can solve.

DRINKING HARD FOR THE MONEY

One afternoon in November 1910, a gentleman walked—or, more likely, staggered—into the customs office in Sault Ste. Marie. The gentleman, a sailor, demanded to be given the pay that he had earned working on one of the many boats that travel through the locks. Everyone present noticed his disheveled appearance. Coupled with his obvious intoxication, the appearance of his clothing and person gave the impression he'd just survived quite a walloping.

The man in charge of the customs office politely informed the sailor that he had the wrong office. Someone else suggested he try talking to Judge Colwell, and the sailor blundered out of the customs office in search of the judge. Once he found Colwell, the sailor reiterated his demand

for payment. Unfortunately, the judge told him that he once again had the wrong office and should try the marine court. Foiled a second time, the sailor made a beeline for the nearest saloon. After enduring a beating and two failed attempts to find the right office where he could get help with his grievances, the sailor seemed to have lost enthusiasm for his quest.

Even a drunken sailor has his limits.

BOOKS FOR THE DEAD

Most libraries are quiet places, almost as quiet as tombs. But when residents of Sault Ste. Marie decided to build a new library, they made it a little too much like a tomb. While excavating the foundations for the new building in 1903, workers dug up more than dirt. Their shovels exposed human remains.

Decades earlier, the site had been used as a military cemetery. Everyone thought the coffins and their associated remains had been relocated years earlier, but they were wrong. The workmen uncovered wooden coffins, many held together by dirt alone, and others completely or almost completely disintegrated. Disarticulated skeletons littered the earth as the workers dug deeper. No complete skeletons surfaced, as most had decayed just like their coffins. Two complete skulls, along with a number of broken ones, came out of the ground during excavation.

Other items came to light too. Bits of cloth, rusted buttons, and a silver plate were uncovered. Pieces of tattered clothing identified the deceased as Union soldiers, while lettering on the plate suggested that at least one woman had also been buried in the cemetery. However, nothing remained that could put names to the bones. The fragments of skeletons were piled on the ground at the construction site. Many bones were stolen by charming characters who, according to the *Soo Evening News*, probably wanted to keep the remains as "souvenirs."

At the time of the library's construction, other buildings in the city were already known to squat atop the final resting places of human beings. The Chippewa Indians had once used the area now home to Sault Ste. Marie as a burial ground. During construction of the old city hall, workers discovered the ground there held countless bones of deceased Indians. So many bones were turned up that some workers didn't want to keep working on the site, though the foremen managed to convince them to keep going. Duncan MacGregor, the man in charge of laying pipes for the city hall, said, "The ground was full of bodies."

The library burned down in 1907, just four years after its construction. It was rebuilt two years later. Authorities blamed the fire on faulty wiring. Maybe the dead were trying to get a message across to the living. If so, nobody listened.

The Extra-Large Skeleton

In the summer of 1908 workmen would make another chilling discovery in the Soo. Men excavating a lot on Water Street found, just two and a half feet below the surface, the skeletons of two individuals. One was a man who in life would have stood well over six feet tall. The other skeleton was smaller and less complete, its sex impossible to determine. Certain traits of the larger skeleton, including its high cheekbones, led to the conclusion the man was an Indian. The size of his bones suggested he was extraordinarily tall and had an imposing and powerful physique. His skull evidenced what the *Evening News* described as "a peculiar deformity." Both skeletons appeared to have lain buried for more than a century. They were sent to the customs office for safekeeping.

The Gypped Gypsy

Everyone knows the warning about looking a gift horse in the mouth. In July 1904 Joseph Lud, the leader of a band of gypsies camped out in the Soo, learned another equine lesson—don't stand too close to a horse for sale.

Lud was examining a horse in hopes of bartering for the beast. He reached a deal with the horse's owner, a man named Forbes. When he took the horse home to his band of traveling friends, however, they discovered the animal

FORGOTTEN TALES OF MICHIGAN'S UPPER PENINSULA

had a nasty habit of kicking. Lud complained to Forbes, who brought his friend Thomas Duke along with him to take a look at the horse at the gypsy camp. Duke held the horse's halter and Lud spoke with the Forbes. Just as Lud began to explain the problem, Duke whipped the halter off the horse's head. The animal threw its head up and bolted off into the woods. No one saw the horse again.

Lud ran straight to the prosecuting attorney in the Soo. He claimed Forbes and Duke had conspired against him to cheat him out of a horse, though the reasons for such a scheme were unknown. At Lud's behest, the authorities issued warrants for the arrest of the two men. Lud may not have wanted the horse, but he didn't want to get gypped either.

ONE LITTLE MISTAKE...

For as long as workers have sought fair treatment from their employers, they have found labor strikes a powerful weapon in their fights. In May 1901 laborers employed at the Soo locks and canal wanted a raise. The previous year their employer, the Lake Superior Power Company, granted them an increase in wages of twenty-five cents per day. In the fall of 1900, however, wages were reduced to the previous level. On May 1 the canal laborers decided they would wait no longer for the return of their pay increase. How could they get their company's attention? They saw but one way—a strike.

They marched from the eastern end of the canal westward, recruiting more strikers as they progressed. Workers from two other companies joined in the demonstration too. By the time they reached the west end of the canal, the strikers numbered over three hundred. The operations of three companies were hindered by the strike, which surely would have driven the laborers' point home, if not for one snag. The laborers who instigated the strike forgot to tell their employer about it.

Most workers strike after negotiations have failed. The canal laborers didn't wait for negotiations to start, much less fail, and they didn't bother asking for the raise beforehand. They just went on strike. Once the strike reached its height, propelled by hundreds of workers, the laborers at last decided to send an envoy to present their demands to the Lake Superior Power Company. The entire assemblage of workers marched back to the company's offices to await their employer's decision. The response was immediate and unequivocal, though perhaps unexpected. The company president agreed to the wage increase but said they would have gotten it anyway had they asked. The company had intended to reinstate the wage increase as soon as the men requested it. The strike was unnecessary.

Why was the company waiting for the men to ask for a raise? Why didn't the laborers talk to their employer before striking? These are questions for the ages.

RULES SHMOOLS

In January 1910 high school students in Sault Ste. Marie rebelled. The *Evening News* proclaimed that "belligerents" had "declared war" on the administration. How did the students wage war, and what triggered the incident?

The administration had instituted strict new rules for student behavior. First, students needed permission from the teacher to leave the classroom. Second, students couldn't gab during class. Third, students must show up for class on time. The punishment for violating the rules was as cruel and unusual as the policies themselves. If a student showed up late, he was required to report to the faculty room to offer his excuse and, if the teachers accepted the reason, the student could go to class. Otherwise, he would have to wait until class ended. As for students who snuck out of the classroom without permission, they would be sentenced to stay thirty minutes after school.

Yes, such policies are unheard of in the world of juvenile academics. How did the students survive? Forced to live under "kindergarten" conditions, the students declared war. In their first salvo, they circulated a petition to express their discontent with the new policies. The administration's response was ruthless. They ignored it. The principal dismissed the rebellion, and its piddly petition, as of little importance. The students gave in to the new rules.

A NOSE FOR TROUBLE

When a city attorney breaks his nose, everybody takes notice. Newspapers as far away as the Soo reported on the incident when Mr. Cuddy, the city attorney for Menominee, smashed his snout in January 1903. While strolling down

the street one day, Cuddy slipped on an icy patch, hit the ground face-first, and broke his beak. By all accounts, Cuddy's nose—large and proudly Roman in character—was a major feature of his face. Everyone wondered whether Cuddy would sue the city for damages.

The gossipmongers may have smelled a lawsuit, but Cuddy didn't. He couldn't sniff out much of anything, after all, with a hurt honker.

WHAT THE DEAD DON'T KNOW...

A cemetery serves as the final resting place for the deceased, where a man's or woman's mortal remains can spend eternity in peace. But in September 1905, the peace of cemeteries all over the UP was shattered, thanks to a gang of vandals.

The trouble started on the thirteenth of September—a Wednesday night, not a Friday—at a cemetery in Wisconsin. The following Saturday night, the action moved across the Michigan border to the Catholic cemetery at Birch Creek, just north of Menominee. A few nights later another Catholic cemetery, this time in Escanaba, became the target. In each case, the perpetrator laid waste to anything associated with the graves, from headstones to statues and crosses, maiming or destroying them with obvious rage. The damage amounted to hundreds of dollars. After the vandals hit Escanaba, the authorities alerted officials

at cemeteries across the UP to the danger. Holy Cross Cemetery, a Catholic burial ground in Marquette, posted guards to watch over the dearly departed overnight. Other cemeteries followed their lead.

Nevertheless, on September 26 the vandals struck a Catholic cemetery in Negaunee in broad daylight. Tombstones and monuments were hacked to bits with hatchets or hammers. Graves were dug up, and debris from the rampage was piled up in the middle of the cemetery. The perpetrators inflicted $3,000 worth of damage on the graveyard, devastating two-thirds of the cemetery. The guards posted at the cemetery had left shortly after 5:15 a.m., allowing the vandals to commit their dirty deeds without getting caught. By eight a.m., they had finished their desecration. The graves exhumed so unceremoniously by the criminals suffered enough damage that no one could tell which coffin belonged in which grave. An armed posse set out in search of the graveyard hooligans, but nobody had a clue as to the identity of the perpetrators. Everyone wondered why they seemed to prey only on Catholic cemeteries. Did they commit the crimes out of anti-Catholic rage?

Later that day, a cemetery in Menominee was hit. Authorities suspected the vandals traveled to their target destinations via the railroad, so cemeteries along the Chicago & Northwestern Railroad were warned to step up their security measures. Meanwhile, a constable in Wisconsin, after talking to eyewitnesses, compiled a

description of the vandal. Yes, as it turned out, one man alone was responsible for the devastation. The suspect was five feet eleven inches tall with a mustache, salt-and-pepper hair, and a thin beard. He wore faded clothes and a black hat and carried a coat over one arm. According to the *Ironwood Times*, one witness who saw the man sneaking into a Protestant cemetery in Wisconsin said he behaved as if he were "out of his mind." The attack of a Protestant cemetery laid to rest the anti-Catholic theory concerning the vandal's motivations. On three separate occasions, suspects were arrested in Manistique, but authorities quickly determined their innocence. Once, officers fired shots at a suspicious person seen in a graveyard after the man ignored their orders to freeze. Nothing came of that incident either.

On September 28 the law caught up with the grave wrecker. At six a.m. that morning, a marshal and his deputy spotted a lone man demolishing headstones in an Ishpeming cemetery. They apprehended the vandal at last. He was a Hungarian called Kose Kazimer, forty-six years old, dressed in faded and bedraggled clothes. Kazimer appeared starved and confused. He carried with him two packages bound in bandannas. One package held a turnip, a book of Catholic prayers, and assorted religious paraphernalia. The second package contained a few items of clothing. Kazimer spoke little English but managed to communicate his belief that he had ravaged the cemeteries in the name of God. He claimed to have visited Escanaba several days earlier, though he had

actually been in Ishpeming for over a week. Based on his behavior and appearance, the *Ironwood Times* described him as giving "evidence of slight mental derangement."

Within a week, authorities became satisfied they had captured the one and only vandal responsible for the cemetery desecrations. Fear of the "gang of ghouls," which gripped citizens for two weeks, dissipated as news of the arrest spread. The guards were relieved of their graveyard shifts. By October 7, the *Ironwood Times* decided Kazimer was nothing more than "a poor, half starved lunatic" who would likely end up in an asylum. As for the dead in Negaunee, whose graves were wrecked beyond recognition, they found ultimate rest in anonymous graves. Cemetery officials couldn't sort out their identities.

What the dead didn't know did hurt them.

RAISING THE ROOF

Charles Bartlett wanted to lift his house, but the house didn't want to move.

In April 1905 Bartlett hired contractors to help him raise his house in Sault Ste. Marie off the ground to make room for a stone foundation. The men had succeeded in lifting the house about a foot and a half off the ground using jackscrews. Charles Bartlett, Harry Bartlett, and two workers crawled under the house to work the jacks. Suddenly, the house shifted, slipping off the jackscrews to

land four feet from its original position. The men trapped beneath the house scrambled to find nooks and crannies in which to hide, to avoid being crushed. Charles Bartlett squeezed between two timbers. Harry Bartlett tried to do the same but ended up pinned under a timber. The other two men suffered cuts and bruises. One of the men standing outside the building was cut by a flying brick. His injury required stitches.

The house settled firmly on top of Harry Bartlett, with a timber pressing down on his back just above his hips. The workmen on the outside struggled to free Harry and, at last, succeeded. A doctor determined his spine was badly injured yet predicted he would make a full recovery.

Three women, including Charles Bartlett's wife, sat inside the house during the hair-raising incident. After the house hit the ground again, they bolted for the front door. It wouldn't open. The accident had not only shifted the house four feet out of place but also warped it to such an extent that the doors would not open. Throughout the house, the plaster on the walls fractured and crumbled. Timbers used as aids in the raising punched holes through the floorboards in the front hall. Pictures tumbled from the walls.

Harry Bartlett's was the only serious injury. No one knew why the house shifted off the jacks. According to the *Evening News*, the contractor in charge of the raising "took every precaution to prevent an accident." Well, maybe not *every* precaution…

Ring of Deception

On April 7, 1903, a Chicago newspaper printed a story about an amazing find in Houghton. A widow called Mrs. Ring discovered in her cellar fifteen kegs brimming with silver, from bits as small as dimes to chunks as large as eggs. The story told how Mrs. Ring's deceased husband, a miner, had gathered the tidbits of silver over the many years he worked in mines. But he kept his stash a secret, even from his wife. For years, she'd thought the kegs in the cellar contained mine refuse, collected by her husband as a hobby. Mrs. Ring only learned of his silver stockpile hidden in the cellar after she popped open the kegs at the suggestion of a friend who worked in the mines. The story ends with Mrs. Ring and her two daughters, formerly headed for the poorhouse, becoming wealthy ladies of leisure.

The *Soo Daily News-Record* tried to check out the story. Their investigation failed to turn up any Mrs. Ring, widowed or otherwise, living in the vicinity of Houghton. On April 10 the *Daily News-Record* printed its version of the story, labeling the tale a hoax and suggesting that "some correspondent has been ringing in a story on the paper in question." Maybe it was a late April fool's joke, or maybe the reporter got a little confused. Maybe, instead of actual silver, the kegs held premium beer worth its weight in silver.

Bibliography

SHAKIN' AND QUAKIN'

Benton Harbor Daily Palladium. "Cause of an Earthquake." November 19, 1902.

Hobbs, William Herbert. *The Late Glacial and Post Glacial Uplift of the Michigan Basin: Earthquakes in Michigan*. Lansing: Michigan Geological and Biological Survey, 1911.

Ironwood Times. "Earthquake Shocks." November 22, 1902.

———. "UP Quake Left Damage in Wake." May 4, 1934.

Marshall Daily News. "Mines Badly Damaged." February 13, 1906.

Marshall Expounder. "Atlantic…Was Shaken." December 2, 1904.

Oshkosh [Wisconsin] *Daily Northwestern*. "Explosion at Marquette." January 27, 1903.

Racine [Wisconsin] *Weekly Journal*. "State Journal." November 14, 1902.

Sault Ste. Marie Daily News-Record. "Earthquake at Escanaba." February 21, 1903.

———. "Earthquake in Copper Country." November 8, 1902.

———. "Hancock Feels a Shock." November 15, 1902.

————. "Houghton's Earthquake." November 14, 1902.

————. "Many Loud Reports Accompanying an Earthquake Which Was Felt in Menominee." March 15, 1905.

THE WILD WOODS

Ironwood News Record. "Wild Man Near Crystal Falls." October 12, 1901.

Marshall Weekly Statesman. "A Supposed Wild Man." September 23, 1887.

Sault News-Record. "The Alleged Wildman Discovered by Crystal Falls Hunters." October 11, 1901.

————. "Is Still at Large: Crystal Falls Wild Man Escapes Capture by Searching Party." October 15, 1901.

————. "A Raving Maniac Found at Escanaba." October 14, 1901.

————. "Story of the Deer River Wild Man." December 17, 1901.

————. "Wild Man Near Crystal Falls." October 10, 1901.

Sault Ste. Marie Evening News. "Demented Woodsman." December 27, 1910.

————. "Ready for Fun: Elks' Bazaar Will Open at Armory Tonight." August 17, 1908.

————. "Wild Man in the Soo: Story of a Fake Show Years Ago." October 21, 1903.

————. "Wild Man Seen in the Woods." October 1, 1904.

————. "A 'Wild Man' Story." October 29, 1909.

UP A CREEK...OR A TREE

Ironwood News-Record. "Aha, the Sea Serpent." August 3, 1895.

————. "Believes in Sea Serpents." August 1, 1896.

———. "Menominee Has a Sea Serpent." July 13, 1895.

Reimann, Lewis C. *Between the Iron and the Pine: A Biography of a Pioneer Family and a Pioneer Town*. Ann Arbor, MI: Lewis C. Reimann, 1951.

Sault Ste. Marie Daily News-Record. "Caught in a Deer Trap." December 2, 1902.

———. "A White Wolf." February 10, 1903.

———. "Wild Ride for Life." December 1, 1902.

Sault Ste. Marie Evening News. "Drove Him up a Tree: Deputy Game Warden Don't like Bear Cubs." August 29, 1904.

———. "Freak Animal Killed." May 8, 1908.

———. "John Quinn's Adventure." July 14, 1904.

———. "Local Storiettes: An Old Time Tale of a St. Mary's Sea Serpent." March 9, 1905.

———. "Rescued from Canal: Steer Found Swimming in Upper Entrance Last Night." September 24, 1904.

———. "Three-Legged Chicken." October 13, 1910.

THE LOST AND THE FOUND

Houghton Mining Gazette. "Found in the Woods." November 1, 1862.

———. "Lost Girl." October 25, 1862.

Jacker, Francis. "Assinins and Zeba: The Two Oldest Permanent Settlements on Keweenaw Bay." *Michigan History Magazine* 6, no. 1 (1922): 315–27.

Sault Ste. Marie Daily News-Record. "Another Body Found." November 28, 1902.

———. "Is Still a Mystery." November 11, 1902.

Sault Ste. Marie Democrat. "A Mystery: Probable Suicide or Accident Opposite Kemp's Dock—The Mystery of a Hat." December 8, 1887.

————. "On Thursday Last the Body of a Man Was Found." June 23, 1887.

Sault News-Record. "The Soo Rapids Holds a Mystery." May 3, 1901.

FLYING FISTS AND SHARP TONGUES

Houghton Mining Gazette. "Couldn't Come It." March 7, 1863.

————. "Hancock Items." August 16, 1862.

————. "Midnight Rows." December 27, 1862.

————. "Nicholas Blick…Was Called a Few Insulting Names." January 7, 1897.

Marquette Daily Mining Journal. "Discontented Dagos." April 30, 1887.

————. "Doughty Dagos." August 20, 1888.

Sault Ste. Marie Daily News-Record. "Last Saturday Night." October 20, 1887.

Sault Ste. Marie Democrat. "Sunday Afternoon Two Tough Looking Characters Engaged in a Fight." September 22, 1887.

TALES OF THE RAILS

Lake Superior Citizen. "Shove a Big Hero: Our Brig Shove Saves One Hundred Lives." May 19, 1894.

L'Anse Sentinel. "The Engineer of an Eastbound Train." June 27, 1891.

Marquette Mining Journal. "A Day or so Ago, When One of the South Shore Passengers Train Stopped." September 7, 1889.

————. "Paid Dear for Their Fun." December 3, 1892.

————. "A Terrible Ride." February 18, 1888.

————. "There Is Scarcely a Branch of Railroad Work." March 1, 1890.

Sault Ste. Marie Daily News. "Almost a Fatal Accident." January 19, 1888.

————. "Narrow Escape of an Unknown Man." January 30, 1901.

Wakefield Bulletin. "A Runaway Train: A Heavy Copper Train Makes Havoc at Marquette." February 23, 1888.

RIPPED OFF

Houghton Mining Gazette. "A Man of the Sneak Thief Order." October 6, 1887.

Ironwood Daily Globe. "I Stole the Pants, Says Guilty Agent." November 20, 1919.

Negaunee Iron Herald. "Burglarized." March 1, 1888.

Sault News-Record. "Youthful Depravity." October 3, 1901.

Sault Ste. Marie Daily News-Record. "Bad Man Is Frank Feeney." March 16, 1903.

————. "Bold Thief Anyway." November 5, 1902.

————. "Had the Goods: Sailor Apprehended with Tub of Butter He Wanted to Dispose Of." November 13, 1902.

————. "A New Method of Robbery." November 5, 1902.

Sault Ste. Marie Democrat. "Was It a Burglar." October 6, 1887.

Sault Ste. Marie Evening News. "Alleged Chicken Thief Caught in West End." March 5, 1910.

————. "Bicycle Thieving." October 6, 1910.

————. "The Police of Escanaba Are in the Possession of a Watch." October 6, 1910.

DONE IN, DONE WRONG

Houghton Mining Gazette. "Shocking Murder at the Cliff Mine." December 13, 1862.

Ironwood Daily Globe. "Hurley Man Wanted to Kill His Wife." November 20, 1919.

Ironwood Times. "A Mysterious Affair." November 23, 1889.

Marshall Daily News. "Mystery in North Woods." September 8, 1906.

Reimann, Lewis C. *Between the Iron and the Pine: A Biography of a Pioneer Family and a Pioneer Town.* Ann Arbor, MI: Lewis C. Reimann, 1951.

Sault Ste. Marie Daily News-Record. "Unknown Man Found Dead." November 17, 1902.

Sault Ste. Marie Evening News. "Cut Her Head Off: Soo Woman Brutally Murdered at Manistique." July 23, 1904.

———. "Probate Court Proceedings Recall a Strange Tragedy." January 2, 1909.

———. "Was It Murder: Human Bones Found Under Ruins of Shanty." September 8, 1906.

THE BAD GUYS

Adrian Daily Telegram. "Three Insane Criminals." July 24, 1903.

Ironwood Times. "Escaped: Keen and Joyce Break Jail." April 19, 1888.

Sault Ste. Marie Daily News-Record. "Is on Trial for Arson." November 8, 1902.

———. "Lifers in a Fight." April 14, 1903.

———. "Two Juvenile Desperados." March 16, 1903.

Sault Ste. Marie Democrat. "Billy McLain Again in Limbo." September 22, 1887.

Sault Ste. Marie News-Record. "The Wound Is a Serious One." December 17, 1901.

DUPED YOOPERS

Ironwood Daily Globe. "Charges Theft; Then He Changes His Mind." May 4, 1920.

Newberry News. "Robbers and Confidence Men Operating at Trout Lake." May 22, 1891.

Sault Ste. Marie Daily News-Record. "Buncoed the Dealer." November 28, 1902.

———. "Escanaba's Shame." February 16, 1903.

———. "Swindler at Work in the Soo." April 6, 1901.

———. "Venison Shipped As Books." November 8, 1902.

Sault Ste. Marie Democrat. "A Clever Attempt at Forgery, Frustrated The Guilty Man Escapes to Canada." November 3, 1887.

Sault Ste. Marie Evening News. "Another Bogus Check." March 25, 1910.

———. "Who Got the Deer?" November 24, 1906.

TALES OF THE INLAND SEA

Forster, John Harris. "Some Incidents of Pioneer Life in the Upper Peninsula of Michigan." In *Collections and Researches Made by the Michigan Pioneer and Historical Society* 27. Lansing, MI: Robert Smith & Co., 1892.

Sault Ste. Marie Evening News. "Early Days on Lake Superior." September 7, 1904.

———. "Ogarita Is Safe." October 4, 1904.

———. "The Old Thanksgiving: Old Captain Relates Details of a Rigorous Experience." November 25, 1907.

Ten Broeck, Joseph A. "Old Keweenaw." In *Collections and Researches Made by the Michigan Pioneer and Historical Society* 30. Lansing, MI: Wynkoop Hallenbeck Crawford Co., 1906.

LORE OF THE FOLKS

Copper Country Evening News. "Mr. John Pomroy, Who Resides on a Farm a Few Miles from Here." December 19, 1896.

Dorson, Richard M. *Bloodstoppers & Bearwalkers: Folk Traditions of the Upper Peninsula.* Cambridge, MA: Harvard University Press, 1952.

Sault Ste. Marie Daily News. "Clergue Says Nay: His Companies Not Figuring on Railway Connection to St. Ignace." February 7, 1901.

AND THE REST...

Cobb, Charles R. "Ho! Gogebic County!" *Michigan History Magazine* 6, no. 1 (1922): 328–45.

Copper Country Evening News. "R.H. Merrick Suffered a Peculiar Accident." April 21, 1897.

Houghton Mining Gazette. "Hancock Correspondence." September 6, 1862.

———. "More Scared than Hurt." October 18, 1862.

Ironwood News Record. "Turns Out an Optical Illusion." November 30, 1901.

Ironwood Times. "A Copper Country Ghost." November 7, 1896.

———. "Kose Kazimer...Has Aroused the Upper Peninsula and Northern Wisconsin." October 7, 1905.

———. "More Cemeteries Wrecked." September 30, 1905.

———. "Vandalism in Cemeteries." September 23, 1905.

Lake Superior Journal. "We Are Frequently Amused." June 19, 1850.

Sault News-Record. "Canal Laborers Struck for $1.75." May 2, 1901.

Sault Ste. Marie Daily News-Record. "A Broken Nose." January 28, 1903.

———. "Found Beech Trees." November 11, 1902.

———. "A Munising Man's Luck." April 14, 1903.

———. "The Story a Hoax." April 10, 1903.

———. "Thought He Was J. Pierpont." November 6, 1902.

Sault Ste. Marie Evening News. "Giant's Bones Found in Soo." July 1, 1908.

———. "Girl Hugging Women." April 25, 1903.

———. "Guards Are Removed: Local Cemeteries Are No Longer in Danger of Tombstone Smasher." October 5, 1905.

———. "Gypsy Makes Complaint." July 23, 1904.

———. "He Nearly Brought Out the Fire Department." June 20, 1903.

———. "House Fell upon Them." April 19 1905.

———. "In Broad Daylight: Band of Vandals Wrecked Cemetery." 26 September 1905.

———. "Intoxicated? Yes—But This Sailor Boy Didn't Care, He Wanted Redress." November 16, 1910.

———. "Ire Is Aroused: High School Students Said to Have Declared War." January 11, 1910.

———. "Library Will Rest on Ashes of Dead." June 20, 1903.

———. "Mystery Unsolved: Identity of Man Without a Memory Not Learned." February 7, 1914.

———. "Tom Leonard Says He Didn't Drive Fast—Patrolman Haller Says He Did." June 20, 1910.

About the Author

Lisa A. Shiel, a resident of Michigan's UP, researches and writes about everything strange, from Bigfoot and UFOs to alternative history. She is the author of six books, including *Strange Michigan* and the award-winning *Backyard Bigfoot*, and she formerly served as president of the Upper Peninsula Publishers & Authors Association. Find Lisa online at BackyardPhenomena.com.